IMAGES
of America

NORWEGIAN
SEATTLE

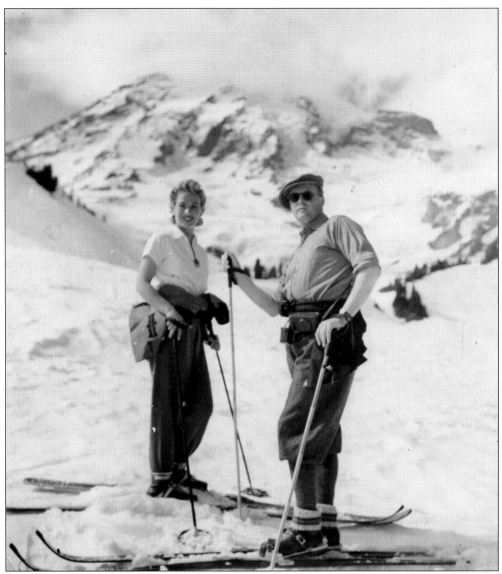

THREE ICONS, 1939. A pretty young Norwegian woman and Crown Prince Olav V were photographed by Gus Raaum on Mount Rainier. The young woman is 20-year-old Gretchen Kunigk. Her Norwegian mother was a skier, and Gretchen first skied at the age of 13 on the south slopes of Mount Rainier. In 1948, as Gretchen Fraser, she became the first U.S. skier, man or woman, to win an Olympic gold medal. The crown prince loved to ski and continued to ski all of his life. (Courtesy Nordic Heritage Museum 1995.178.001.)

ON THE COVER: Seattle's first Daughters of Norway lodge Valkyrien formed in 1905. Norwegian women in Seattle had their choice of two lodges during much of the 20th century, Breidablik and Valkyrien. Ruth Tollefson (fourth from left) and a Mrs. Krogstad (fifth from left) are in this Valkyrien photograph from 1922. (Courtesy Mina Larsen.)

IMAGES
of America

NORWEGIAN
SEATTLE

Kristine Leander

ARCADIA
PUBLISHING

Published by Arcadia Publishing
Charleston SC, Chicago IL, Portsmouth NH, San Francisco CA

Printed in the United States of America

Library of Congress Catalog Card Number: 2008928801

For all general information contact Arcadia Publishing at:
Telephone 843-853-2070
Fax 843-853-0044
E-mail sales@arcadiapublishing.com
For customer service and orders:
Toll-Free 1-888-313-2665

Visit us on the Internet at www.arcadiapublishing.com

CONTENTS

ACKNOWLEDGMENTS

I am deeply indebted to everyone who helped me. Whether you maintain photographs and archives as part of your job or just for the love of it, I appreciate you. Thank you! *Norwegian Seattle* would not have been possible without you: Julie Pheasant Albright; Christine Anderson; Margaret Anderson; Rosemary Antel; Sonja Beck; Anne-Lise Berger; Knute Berger; Hazel Brygger; Barbara Grande Dougherty; Anita Endresen; Diana Erickson; the Fisherman's Memorial; the Haavik family; Sig Hansen; Lisa Hill-Festa (curator, Nordic Heritage Museum); Glory Frodesen; Olaf Kvamme; Mina Larsen; Solveig Lee; Rolf Lystad; John Mahlum; Carolyn Marr (librarian, Museum of History and Industry); Mithun, Inc.; Lynn Moen; Ron Olsen; Einar Pedersen; Claire Sagen; Alice Sagstad; Sissel Peterson; Sandaas family; Anne Marie Steiner; Gordon Strand; Julie Svendsen; and Marilyn Whitted.

I also thank those who helped me indirectly—the foresighted, but mostly unknown, individuals who placed their photographs in publicly accessible archives, such as the Museum of History and Industry, the Nordic Heritage Museum, and the University of Washington Libraries, Special Collections. If your family or club is not represented here, I hope you will submit photographs to these resources so that your story is available to the next historian or researcher.

My greatest appreciation is for the individuals whose photographs and stories are included in *Norwegian Seattle*, some well known and some unknown. Thank you for allowing me to compile the story of a community for which I have immense respect and affection.

INTRODUCTION

In the pages to come, readers will learn about the traits the Norwegians brought to Seattle—traits that were a result of Norway's harsh environment and social history before the era of emigration. There had been no surplus to support an upper class in Norway's hardscrabble environment, and so the emigrants were egalitarian. Conditions in Norway also led to traditions of mutual aid, working cooperatively, sharing equipment, and participating in community affairs. Long, cold winters and limited areas of farmland developed the ability to work hard and ignore physical danger. Long nights with plenty of time spent indoors fostered a love for well-built homes and architecture. The spectacular natural environment produced people who loved nature and being outdoors. Isolated farms developed resourcefulness, and the Lutheran tradition of every person being able to read the Bible meant that they were mostly literate. Deep-seated memories of the plague and more recent experiences with tuberculosis led to a respect for cleanliness. Men often went to sea, so the women were independent and strong, used to supporting themselves and their families for months on end.

All was not work or hardship. There had also been time in the homeland for singing, dancing, and playing music and games, storytelling and gossip, worship, feasting, courtship, and celebrating. These too they brought to America.

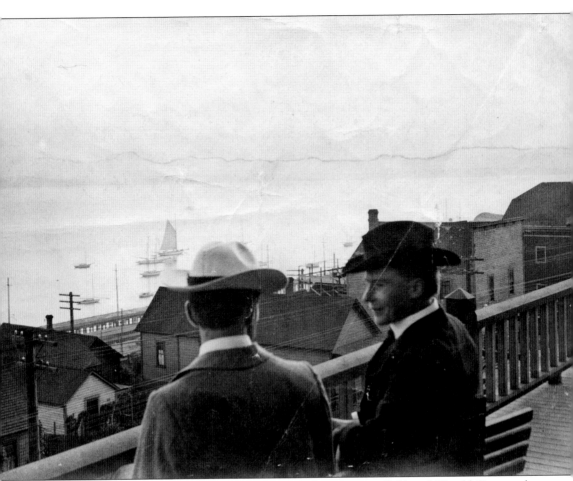

"To Sport fra Seattle," c. 1905. Soon after brothers Severin (left) and Harald Gangmark arrived in Seattle, they bought cowboy hats and had their photograph taken looking out over the town. The back is inscribed in Norwegian: "Two sporty guys from Seattle." Severin was a self-employed painter and did much of the painting and rosemaling of Norway Hall. Harald became part owner of the Fisheries Supply Company. (Courtesy Julie Svendsen.)

One

From Early Pioneers to the Alaska Yukon Pacific Exhibition
1870s to 1909

"Those Norwegians are as good a class of immigrants as our Territory can possibly be peopled with, as they are noted the world over for their industry, economy, honest dealing and steady habits." Thus wrote Thomas W. Prosch, editor of the *Weekly Pacific Tribune*, in an April 1876 editorial, 13 years before Washington became a state.

Pioneer Norwegians were welcome, and their skills stood them in good stead. The growing community required housing, so loggers and carpenters found jobs. (After Seattle's Great Fire of 1889, when the population nearly doubled, the city needed even more lumber, bricks, and builders.) Puget Sound waters offered two opportunities, food and transportation, so fishermen and boatbuilders went right to work. The growing society's need for civil servants such as policemen and politicians attracted Norwegians who came with a thousand years of democracy in their genes.

Norway prepared them well, but the new society put more than their skills to use. What they had learned from the land they left behind, infused in the soul of the Northwest. Resourcefulness that had developed in isolated valleys of Norway, neighborly cooperation in good times and bad, strength and independence in women who supported families while men were at sea, ingenuity in extracting a livelihood from a stingy environment, and a high level of literacy in their Lutheran society—these were the useful qualities they brought to the new frontier.

One Norwegian pleasure fit in well in the Pacific Northwest: enjoying the outdoors. These early Norwegians loved the land and scenery they had left, and they eagerly swam, picnicked, camped, and learned what nature in this area had to offer. And one particular Norwegian value became a necessity—cooperation and mutual aid. It was evident in their singing groups, churches, and clubs. Churches were a haven for new immigrants and a place to learn American language and culture. Clubs such as the Sons of Norway actually started as mutual aid groups for Norwegians with wage loss, sickness, or death. Whatever the immigrants' apparent reason for these early associations, their need for support was met.

The chapter ends with the Alaska Yukon Pacific (AYP) Exhibition. To the adventuresome immigrants who attended the AYP, it was bigger and more exciting than a world's fair. Thanks to cheap railroad fares, they traveled from all over the country to see what Seattle had to offer and to be with other Scandinavians. The AYP lived in their memories for the rest of their lives.

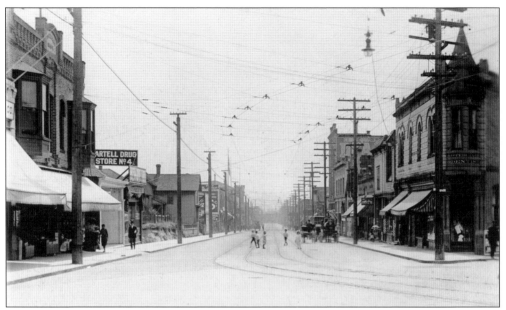

BALLARD STREET SCENE, 1920. Wide-open streets, trolley tracks, automobiles, and horseless carriages existing together—this was the scene from Ballard Avenue looking east from Twenty-second Avenue. Note the Bartell Drug Store No. 4. Bartell Drugs started in Seattle after the Klondike gold rush. (Courtesy Nordic Heritage Museum, 88.43.8.)

FISHING NETS, C. 1909. Chris Nelson was a fisherman who stored his nets at the foot of Twenty-eighth Avenue NW in Ballard. Before the Chittenden Locks were built, he could walk across to the Magnolia side during very low tides. This is in front of the site of the future Nordic Heritage Museum, for which Nelson's grandson, Gordon Strand, was heavily involved in the planning. (Courtesy Gordon Strand.)

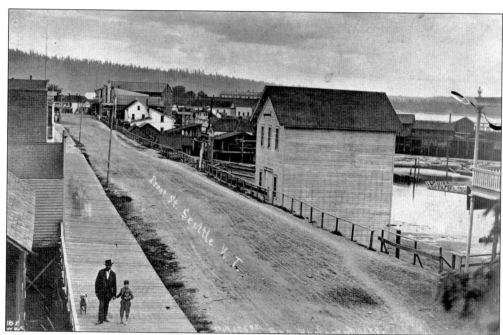

FRONT STREET, SEATTLE, WASHINGTON TERRITORY, C. 1878. Henry and Lewis Peterson were important Norwegian photographer brothers who captured the early days of the city. This is present-day First Avenue at Madison Street. It shows Seattle's first major public works—the grading of Front Street from a stump-strewn, ravine-ridden path to a filled-in, smoothed-out street with a sidewalk. (Courtesy Museum of History and Industry, Pemco Webster and Stevens Collection, 83.10.6138.)

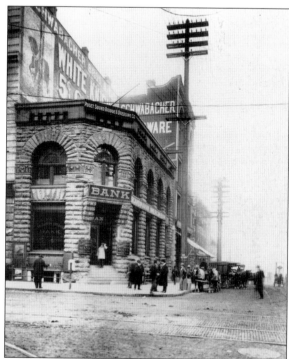

SCANDINAVIAN AMERICAN BANK, 1904. The bank on Seattle's First Avenue South and Yesler Way was organized in 1892 with a balance of $75,000. A Swede, Andrew Chilberg, was president, and many Norwegians banked there. It closed its doors in debt in 1921. (Courtesy University of Washington Libraries, Special Collections, A. Curtis, 04090.)

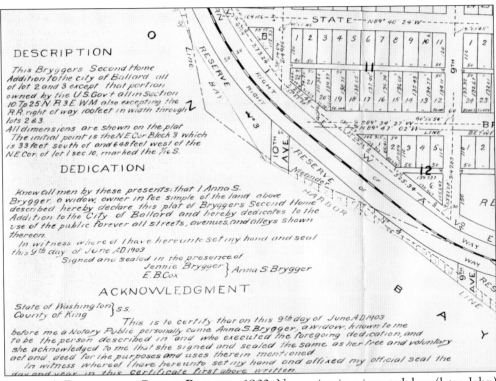

BRYGGER'S DEED TO THE CITY OF BALLARD, 1903. Norwegian immigrants Johan (later, John) and Anna Sophia Brygger were the first Norwegian family in Ballard, and their home is the current Lockspot Café. When the city of Ballard paved streets and sidewalks and put in sewers, Anna was widowed and did not have the money to pay the assessment. The city took over most of her property for payment. (Courtesy Hazel Brygger.)

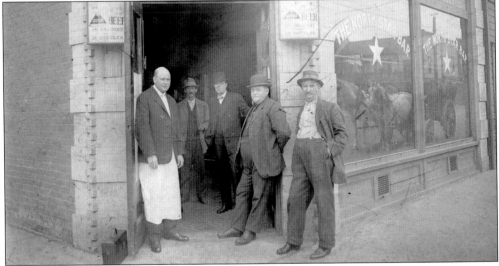

CORNER OF BALLARD AVENUE AND DOCK PLACE, 1916. The North Star Bar was a favorite of Norwegian American men. At one time, Ballard Avenue had more saloons per square foot of boardwalk than anywhere west of the Mississippi. Note the reflection of the horse in the window. (Courtesy Margaret Anderson.)

REGINA SCHILLESTAD, C. 1876. Ole Schillestad and his wife, Regina Inge Borg Schillestad, were an early—if not the first—Norwegian family to come to Seattle. The Schillestads were related to the Bryggers and the Peterson brothers and their wives, important early Norwegian families. (Courtesy Museum of History and Industry, 15,137.)

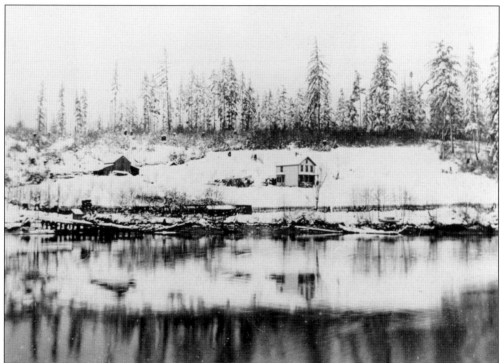

SCHILLESTAD HOMESTEAD, C. 1900. One of the first Norwegian families in Seattle, Ole and Regina Schillestad homesteaded on the Magnolia side of Salmon Bay. Ole built this house and the home of his in-laws John and Anna Brygger. They lived across from the Chittenden Locks and had an orchard. After the locks were built and the water rose, they rowed out to pick fruit from the tops of their trees. (Courtesy Museum of History and Industry, SHS 4681.)

"Undertaker, Upholsterer and Furniture Manufacture," 1865. Harsh conditions in Norway produced immigrants who were resourceful and opportunistic. Trained as a carpenter, Ole Schillestad was in business with a partner for a while, and their sign offered the services mentioned above. Like other early Norwegians in the West, he and his wife lived first in the Midwest. This photograph was taken before they came to Seattle. (Courtesy Museum of History and Industry, 2002.50.118b.)

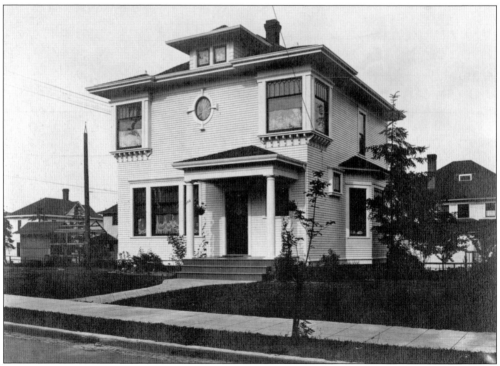

Schillestad Home on Capitol Hill, 1908. Ole Schillestad was a carpenter and probably built this home at 532 Malden Avenue East for his son and daughter-in-law, Alfred and Lucy. As a young man, Alfred drew in sketchbooks and created a unique visual record of early life along the shores of Salmon Bay. (Courtesy Museum of History and Industry, 2002.50.118a.)

ISAAC OLESON, EARLY TERRITORIAL LEGISLATOR, c. 1885. In the Viking era, Scandinavians formed the first representative governments. For hundreds of years afterward, the Norwegian people yearned to be self-governing, and so the immigrants took to politics like goslings to water. Isaac was an early-day legislator before Washington achieved statehood on November 11, 1889. (Courtesy Museum of History and Industry, SHS3472.)

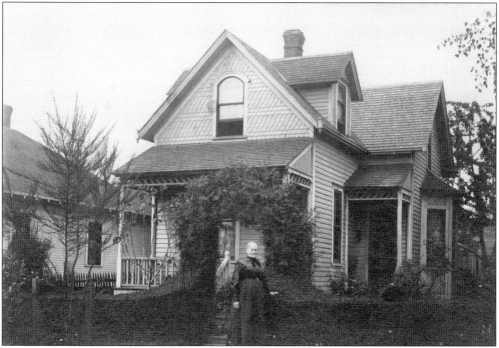

OLESON HOME, C. 1890. Sarah Oleson stands in front of the Ballard home she and Isaac lived in at 2416 Northwest Sixty-Fourth Street. The home is still standing. Washington achieved statehood in 1889 and had one of the earliest and most liberal views toward women's suffrage. Some practical legislators hoped this would bring more women to the state—or perhaps it was the influence of Scandinavians who were used to women as equal partners. (Courtesy Museum of History and Industry, SHS3473.)

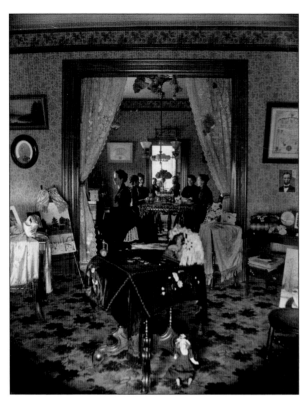

PETERSON HOME, 1900. Henry Peterson and his brother Lewis were well-known early Seattle photographers who arrived from Norway in 1875. This view is of Henry's home at Fourteenth Avenue and Madison Street on Capitol Hill. Photography was important to the consciousness of the infant city, but the Great Fire of 1889 destroyed the work of many early photographers. Luckily, much of the Peterson brothers' work remains. (Courtesy Museum of History and Industry, 2002.50.120.)

ANNE HERBERG, FARMER, c. 1890. Probably no emigrant-sending country produced more independent women than did Norway. Milking was often women's work, and women were used to caring for the farm and family for months at a time while the men were at sea. Anne was born in Gudbrandsdalen, came to Seattle in 1887, and lived on a dairy and vegetable farm on Dayton Avenue, near Greenlake. (Courtesy Museum of History and Industry, 15126.)

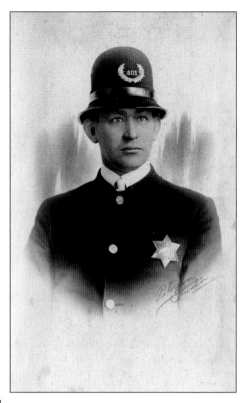

POLICE OFFICER ALBERT JULIUS HANSEN, 1914. Hansen was born to Norwegian parents in Minneapolis in 1885 and came to Seattle in 1890. He operated a bakery in the Interbay area, but wanting a more stable job to woo a young Swedish woman named Helen Zeek, he joined the Seattle Police Department. They were married in 1914, and he retired in 1941. In the photograph below, they are cutting up together in the backyard. For his police work, Hansen kept a stack of preprinted courtesy reminders to hand out instead of tickets, advising drivers: "If everyone who takes the wheel would say a little prayer/and keep in mind those in the car depending on his care/and make a vow and pledge himself to never take a chance/the great crusade for safety, then suddenly would advance. Your cooperation requested by Officer A. J. Hansen." (Both courtesy Museum of History and Industry, 2002.35.1 and 2002.35.6.)

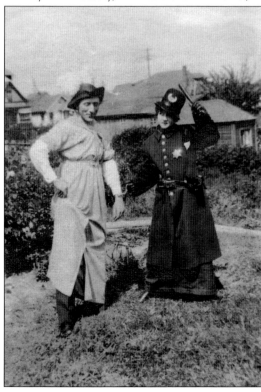

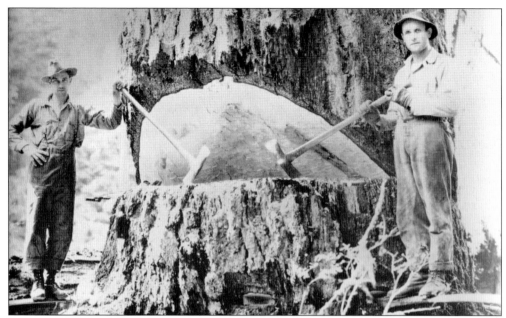

LOGGERS, EARLY 1900S. In the construction boom in Seattle after the Great Fire of 1889, many buildings needed to be replaced. This, together with the subsequent influx of population, created a need for housing and, therefore, lumber. Norwegians and other Scandinavians were eager to work in logging, just as they had before they left home. (Courtesy Ron Olsen.)

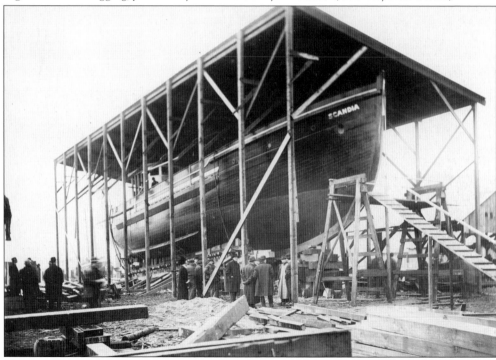

HALIBUT SCHOONER SCANDIA, 1914. Ballard Boat Works, owned by Sivert Sagstad, built this 90-foot schooner. It was dieselized in 1923 and sank near Kodiak, Alaska, on February 23, 1927, while tagging halibut for the International Fisheries Commission. (Courtesy Alice Sagstad.)

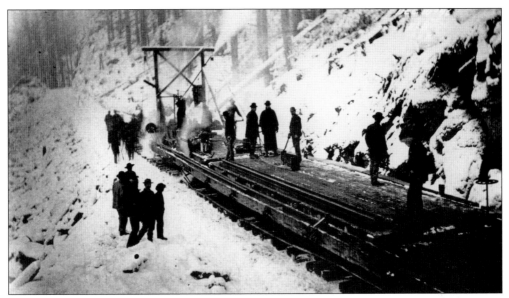

RAILROADS BROUGHT IMMIGRATION, 1892. The railroad was integral to Norwegian immigration to the Pacific Northwest. Immigrants came to help build the railroad, and after it was finished, others were able to come. Norwegian workers were used to long hours in cold weather and deep snow. This photograph of the laying of the last rail was taken west of the summit at Stevens Pass by Norwegian Anders Wilse. (Courtesy Museum of History and Industry, SHS11033.)

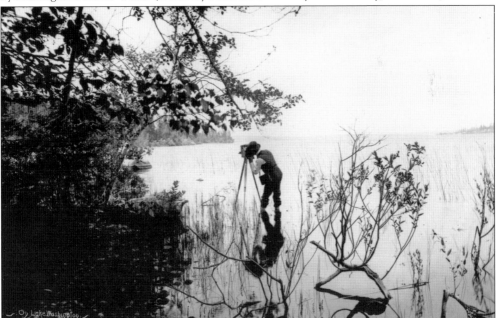

ANDERS WILSE, NORWEGIAN PHOTOGRAPHER, 1900. Wilse's photographs documented Seattle in the late 19th century and Norway in the early 20th century. He immigrated and worked as a civil engineer, cartographer, and assessor, and then became a full-time photographer of local scenery and the city. Here he stands in Lake Washington with his camera. After 17 years he returned to Norway and became one of Norway's most famous photographers. (Courtesy Museum of History and Industry, 11026.)

THEA AND ANDREW FOSS, EARLY 1900S.
The Foss Maritime Company was started by Thea and Andrew Foss. In 1889, when Andrew left to work in another part of the state, Thea purchased a rowboat for $5, painted it green and white, and rented it out. When Andrew returned and discovered she had made more money than he had, he began constructing rowboats. In 1920, the business moved to Seattle. (Courtesy Nordic Heritage Museum, 1999.060.080.)

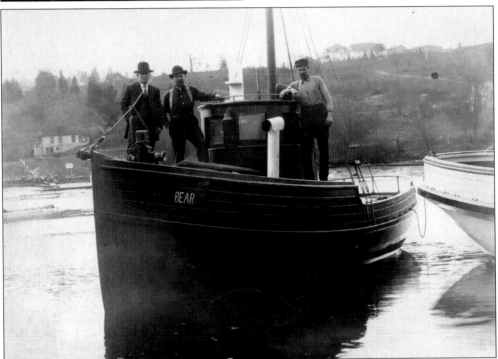

THE TUGBOAT BEAR, C. 1910. Boatbuilder Sivert Sagstad built the *Bear* and used it as a tugboat and a family recreation boat for picnics. Before the Chittenden Locks were built in 1916 and the Ballard Bridge in 1917, he charged 15¢ to ferry passengers across the water to the Magnolia side, shown in the background. (Courtesy Alice Sagstad.)

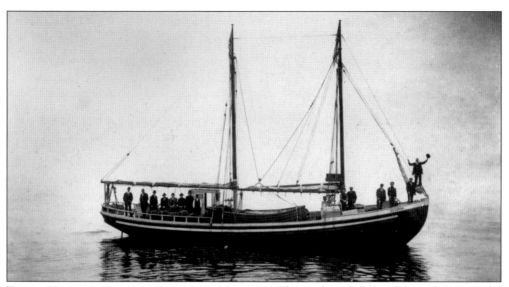

Early Halibut Fishing Boats, 1908, 1912. The earliest halibut fishing boats in the Northwest were sailing schooners, such as the *Decorah* (above). The vessel was based in Ballard and belonged to Norwegian immigrant fisherman Ove Rommen. Note the formal wear, indicating that no one intends to fish on this trip. Ove Rommen also owned the boat below, a halibut-fishing, sailing schooner, the *Jennie F. Decker.* The Cholpeck Fish Company was on a wharf at the foot of Wall Street. (Above, courtesy Museum of History and Industry, SHS 15526; below, courtesy Museum of History and Industry, 15529.)

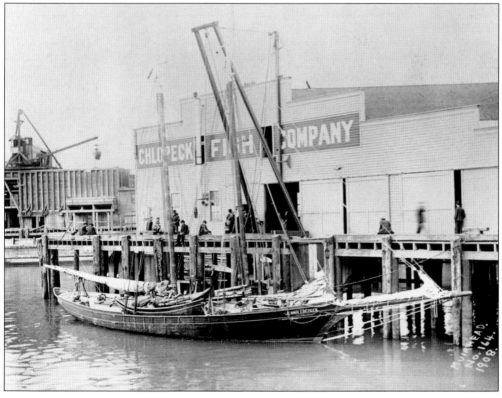

SIVERT SAGSTAD, BOATBUILDER, 1909. Sagstad immigrated in 1905 and established the Ballard Boat Works within months of arriving. He was a pioneer and craftsman among boatbuilders. His reputation—and many of the 300 boats he built—outlived him. This is his first boatyard, close to the railroad bridge near Shilshole Bay in Ballard. Around 1924, he moved his boatbuilding operation to the foot of Twentieth Avenue NW. (Courtesy Alice Sagstad.)

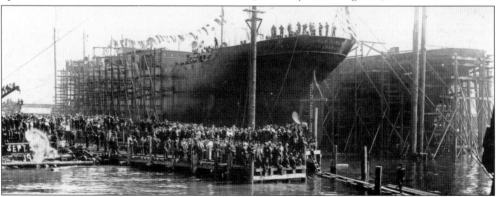

LAUNCHING STEAMSHIP NIELS NIELSEN, 1916. Todd Shipyards on the Seattle waterfront built the *Niels Nielsen* for the Norwegian shipping firm B. Stolt-Nielsen. She was the first merchant steamship built there for foreign owners and is shown here at the launching in September 1916. (Courtesy University of Washington Libraries, Special Collections, UW 27676.)

ANDERSON BOATHOUSE DURING FISHING SEASON, 1911. The Anderson family lived in this boathouse at the foot of Twentieth Avenue in Ballard. Capt. Fred Anderson, his wife, Gulla, and her sister Laura Christoffersen, holding her daughter Lillian, are standing on the deck. Fishing season meant that all the boats were out. (Courtesy Margaret Anderson.)

THE BIG SNOW OF 1916. Everyone remembered the big snow of 1916 and talked about it for decades afterward. At the Anderson boathouse, the tugboat *Floyd* is moored along with the *Alfa*, *Racie*, and *Nansen*. Note the shingle mill in the background, where many Norwegian men worked. (Courtesy Margaret Anderson.)

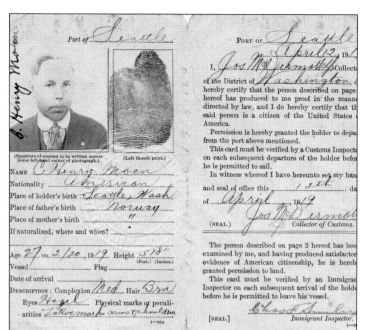

HENRY MOEN'S SEAMAN'S CARD, 1919. C. Henry Moen was an industrious young man and an avid amateur photographer with curiosity and a keen sense of humor. As a youth, he used a 5-by-7-inch view camera and glass plate negatives that he developed in a bedroom closet. Readers will see several of his photographs later in this section. As an adult, he had many odd jobs; he eventually became a seaman and crossed the Pacific Ocean more than 200 times. (Courtesy Lynn Moen.)

RECEPTION ON FISHING BOAT, 1919. Before leaving for fishing, it was customary to clean the boat and have everything sparkling, make lots of food, and then invite friends and family for a reception. Louise and Louie Holm (left) and Louise's cousin John Harmon are shown here on the *White Star*. The view of downtown Seattle before Denny Hill was razed is from Pier 62. (Courtesy Margaret Anderson.)

24

Successful Fisherman's Wife, 1928. Karen Kristine Skeisvold Nilsdatter was born in Norway in 1886 and came to America around 1905. In Seattle, she married a Norwegian fisherman. After one successful fishing trip, he invited her to go buy a hat. So she did. (Courtesy Margaret Anderson.)

"God Mat," 1917. The Anderson family often had summer picnics on the tugboat *Floyd*, named after their son. Here they are near Bainbridge Island, their favorite place for a trip. This photograph was made into a postcard with the inscription *"god mat"* (Norwegian for "good food"), indicating that they thought they were eating well. Note that everyone was dressed up for the picnic, which was common in those days. (Courtesy Margaret Anderson.)

BOAT PARADE FOR OPENING OF FISHERMEN'S TERMINAL, 1914. Chris Nelson's purse seiner *Inga* leads the parade of 200 fishing boats. Captain Nelson was active in the community and knew what was necessary to get along in a new society. He was willing to hire men soon after they arrived from Norway, but he always told them, "If you want to be on the crew next year, you have to learn English." (Courtesy Gordon Strand.)

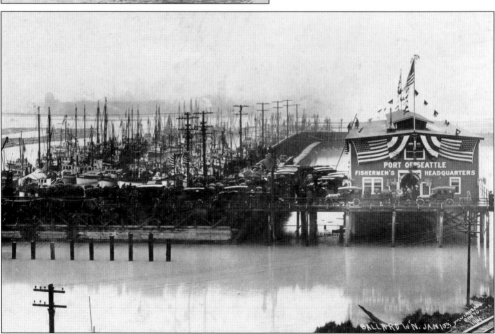

OPENING OF FISHERMEN'S TERMINAL, 1914. The newly formed Port of Seattle, established in 1911, had selected the present site of Fishermen's Terminal to be a deep-sea boat harbor. When it proved unfeasible, the Puget Sound Fisheries Association lobbied the port for a publicly owned home for Seattle's fishing fleet. It was opened on January 11, 1914. (Courtesy Alice Sagstad.)

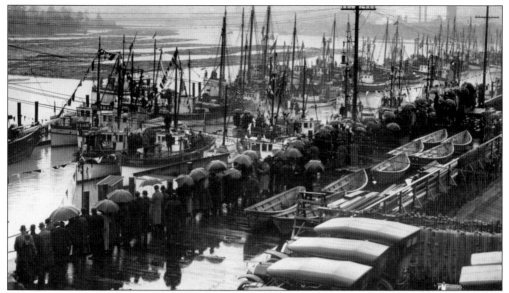

CROWDS ATTEND THE OPENING, 1914. A rainy January day did not keep the crowds from watching the opening of Fishermen's Terminal. Perhaps the mayor was somewhat begrudging when he declared, "The fishermen have voted [and we'll have a Fishermen's Terminal]." Note the smokestacks of Ballard in the background. (Courtesy Gordon Strand.)

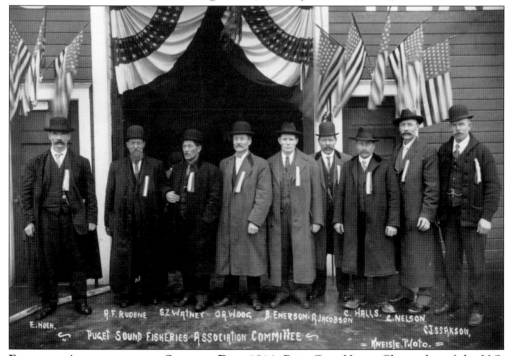

FISHERIES ASSOCIATION AT OPENING DAY, 1914. Brig. Gen. Hiram Chittenden of the U.S. Army Corps of Engineers and an original port commissioner described the mission of the new terminal: "To organize and solidify the scattered fishing industry of the Northwest . . . provide a home for the fleet . . . [and] give such aid as to protect the fisherman in marketing his hard-earned products." (Courtesy Gordon Strand.)

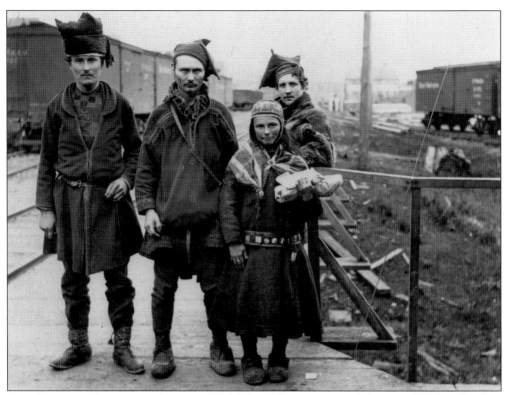

SAMI HERDERS BOUND FOR ALASKA, 1898. The U.S. government-led move of 77 Sami herders and 500 reindeer was intended to relieve a perceived famine among the Yukon gold miners and native people. They first sailed to New York and were then transported by railroad across America. Around 8,000 people visited Woodland Park in one day to see the reindeer and their herders. (Courtesy University of Washington Libraries, Special Collections, A. Curtis, 46196.)

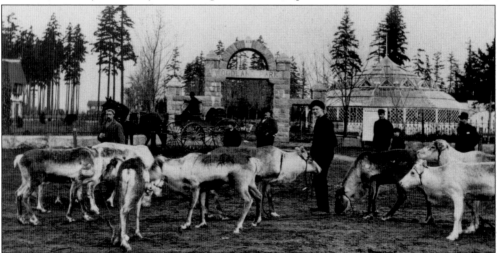

REINDEER AT WOODLAND PARK, 1898. The Lapland-Yukon Relief Expedition from Norway to Dawson, Alaska, took one year. The reindeers' antlers were removed, and the planners were inexperienced with the diet of reindeers in the wild. Most of the animals died from starvation and exhaustion. (Courtesy University of Washington Libraries, Special Collections, UW 5001.)

GUNNAR LUND, EDITOR OF *WASHINGTON POSTEN*, c. 1905. During the 19th century, Frank Olsen and his brother decided to publish a Norwegian newspaper in Seattle. *Washington Posten* launched on May 17, 1889, the same day as Seattle's first 17th of May parade. The original price was $1.50 a year, later reduced to $1. After several other owners, Gunnar Lund purchased it in 1905. From a circulation of 2,900, it rose to 8,000 in 1915. The office was located at First Avenue and Cherry Street. (Courtesy Nordic Heritage Museum, 1997.48.)

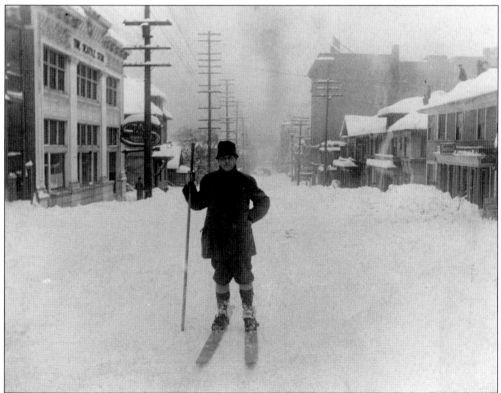

THE BIG SNOW, 1916. Twenty-nine inches of snow fell in February 1916. L. C. Twito is shown at the center of Sixth Avenue near University Street in downtown Seattle. He and other Norwegians made their own skis and thus had no problem getting around. (Courtesy Museum of History and Industry, SHS 15036.)

YOUNG WOMEN IN BALLARD, 1912. The girls are, from left to right, Helen Vick, Martha Jacobson, Margaret Vick, Lillian Erickson, and Florence Erickson. The photograph is by Carl Henry Moen. He loved photographing his family and friends around his Ballard neighborhood and was only 19 or 20 years old when he took this picture. (Courtesy Museum of History and Industry, 1980.6880.302.)

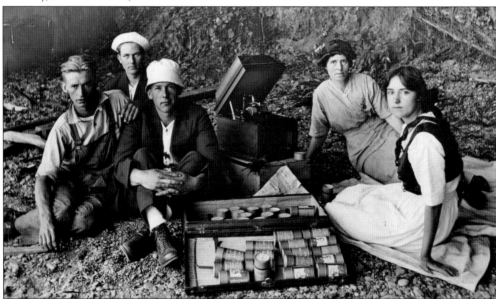

TEENAGE MUSIC AT THE BEACH, C. 1913. Just like teens of today, these young people liked to listen to music at the beach. They had rowed from Ballard over to Bainbridge Island with a phonograph that played wax cylinder recordings. Ed Moen is the young man in the center, and Jake Jacobsen is also in the photograph, which was taken by Carl Henry Moen. (Courtesy Museum of History and Industry, 1980.6880.317.)

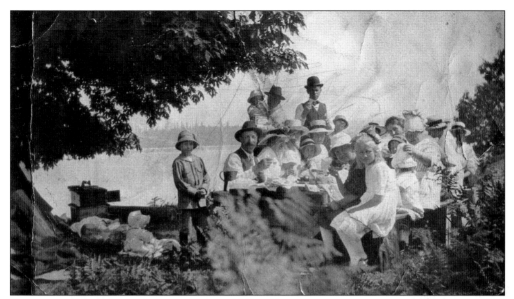

PICNIC ON BAINBRIDGE ISLAND, EARLY 1920S. Picnics, enjoying nature, and being together outside were all important to the Norwegian American community. The Anderson family loved to go for picnics at Rolling Bay on Bainbridge Island. Note the phonograph on the ground and the well-dressed picnickers, who had probably traveled to the island on their tugboat, the *Floyd*. (Courtesy Margaret Anderson.)

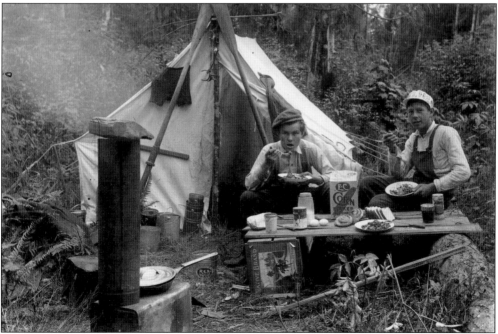

CAMPING CLOSE TO HOME, 1910. Families with cars could drive out of town for picnics and camping, but many Ballard families spent their time in nature—even camping—in locations close enough to walk. Glen Bigelow and Ed Moen are camping just north of Ballard. Note the stove in the left foreground, made from a square can and a stovepipe. The photograph is by Carl Henry Moen. (Courtesy Museum of History and Industry, 1980.6880.2337.)

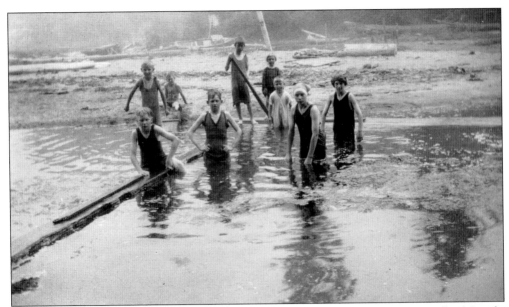

SWIMMING AT BALLARD BEACH, 1920. The Anderson family is swimming at Ballard Beach, near the site of the present Shilshole Bay Marina. Note the long bathing suits. These Norwegian Americans must have been hardy folks. Beachgoers in the same area today rarely go out in the cold water. (Courtesy Margaret Anderson.)

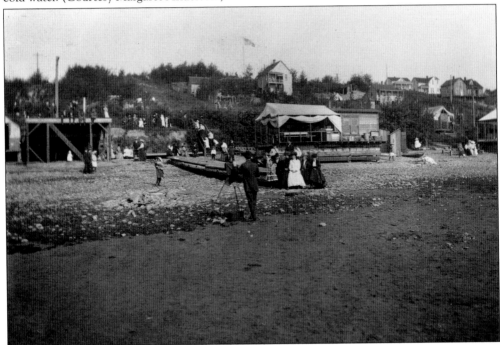

AN AFTERNOON AT BALLARD BEACH, 1910. This photograph shows all the activity at Ballard Beach, from boathouses to bandstands. Note how dressed up the ladies are. Today Sunset West Condominiums occupy nearly the same location. The photograph is by Carl Henry Moen, who is displaying his sense of humor by photographing the photographer. (Courtesy Museum of History and Industry, 1980.6880.126.)

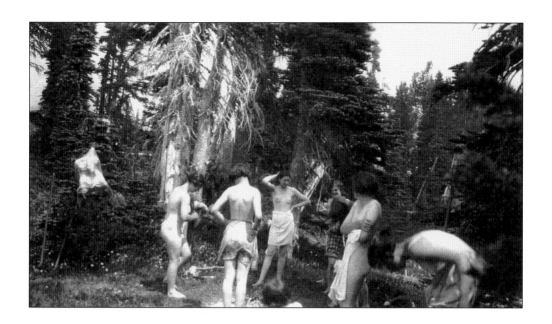

TAKING A DIP IN THE WOODS, C. 1915. A group of mostly Norwegian young women from Seattle's Alpine Hiking Club walked the three-day Wonderland Trail around the base of Mount Rainier. Two of the women were Laura and Emilie Brekke, daughters of early Ballard's Norwegian blacksmith, Lars Brekke. Unlike other picnics in this era when everyone dressed up to be out in nature, for a short while, these young women went in the other direction. (Courtesy Lynn Moen.)

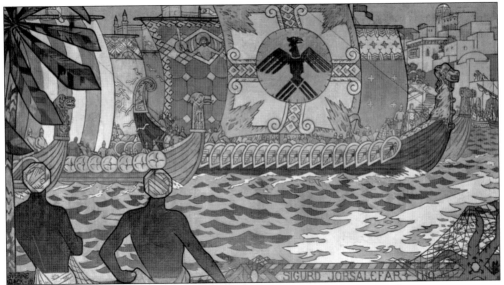

YNGVAR SONNICHSEN, MURAL ARTIST, 1915. In 1914, the local Norwegian American community commissioned three men to design and decorate a meeting hall that would remind them of their homeland and heritage. Architect Sønke Sonnichsen, his artist brother Yngvar Sonnichsen, and another artist, Sverre Mack, were selected to design Norway Hall and decorate it with original oil-on-canvas murals and paintings. Yngvar also exhibited his art at the Alaska Yukon Pacific Exhibition and taught at the art school that moved to Beaux Arts in Bellevue. The mural above is titled *King Sigurd the Crusader Sailing into Constantinople Anno 1110*. Sverre Mack painted four of the seven murals, including this one. (Above, courtesy Museum of History and Industry, 1983.10.14917.4; below, courtesy Museum of History and Industry, SHS7608.)

DAUGHTERS OF NORWAY PRESIDENT, c. 1910. In 1905, the two-year-old Leif Erikson Lodge of the Sons of Norway chartered the Valkyrien Lodge of the Daughters of Norway. The men also offered to make the new lodge subordinate to their club, but the women soundly rejected it. Valkyrien's first president, Nicoline (Lina) Hamstad, emigrated from Oslo at age 17. (Courtesy Museum of History and Industry, 15.112.)

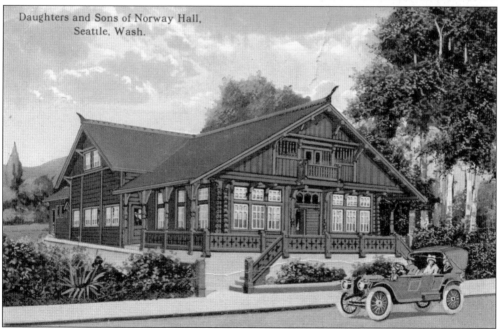

NORWAY HALL, c. 1920. Norway Hall was built on Boren Avenue in 1915 to house the activities of several Norwegian groups. In the early days, many gathered regularly for dancing there. The architecture incorporated traditional Norwegian design elements such as the elaborately carved dragon heads on the gable ends. It became a Seattle Landmark in 1975. The Cornish College of the Arts uses it now as a performance hall. (Courtesy Nordic Heritage Museum 82.7.1d).

17TH OF MAY QUEEN, 1913. Olga Nelson (later, Opsal) was chosen as queen of the festivities for the 17th of May. She was chosen over other candidates, and she probably gave this photograph to one of her supporters in appreciation for helping her become the queen. Her father, Louis Nelson, operated a bar on Ballard Avenue, and the family lived on State Street, which is now Fifty-sixth Avenue NW. She was a fitting choice to reign over Ballard's celebration, as she had been born the day Ballard was incorporated as a city, January 1, 1890. Incidentally, Ballard was the first community to incorporate after Washington achieved statehood in 1889. (Courtesy Gordon Strand.)

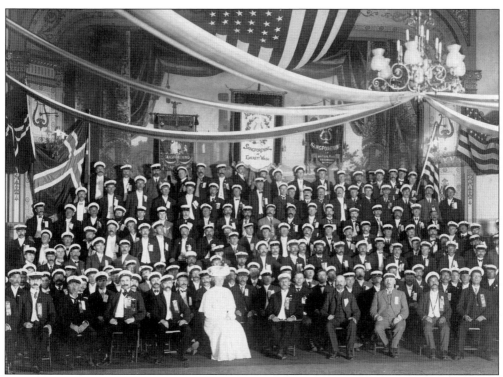

Norwegian Singers Festival, c. 1910. The prominence of the Everett group's banner in the back may indicate that the singers' festival, or *sangerfest*, was held there. The first Pacific Coast Sangerfest was hosted by the one-year-old Everett Norwegian Male Chorus in 1903. If this photograph is not of the first Pacific Coast Sangerfest, it is indeed an early one. (Courtesy Nordic Heritage Museum, 2005.20.1)

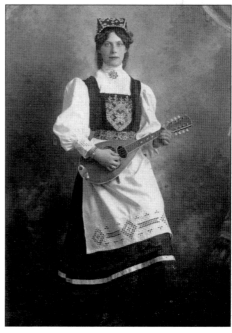

Laura Christoffersen in Her Bunad, 1908. The breastplate of this traditional *bunad* from Hardanger is still in the family, as is the mandolin. Laura probably learned to play it in Norway. Laura was the mother of Lillian Christoffersen, who was active in the Norwegian American community. (Courtesy Margaret Anderson.)

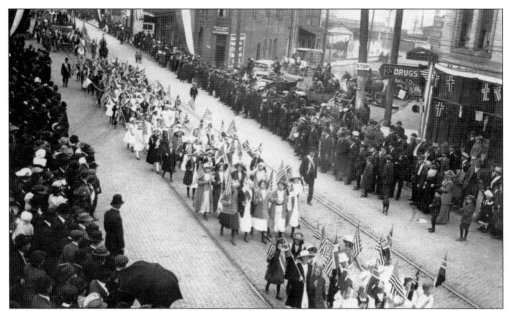

17TH OF MAY PARADE, C. 1905. The Norwegian American community in Seattle began staging a 17th of May parade in 1889. Here the parade moves westward along Market Street in Ballard. Just like today, there were nearly as many walkers as watchers. Note the carriages and automobiles parked alongside each other on the street. (Courtesy Nordic Heritage Museum.)

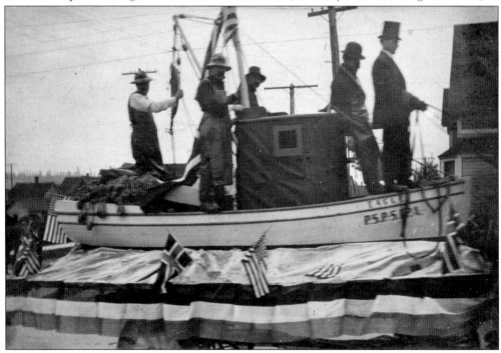

17TH OF MAY FLOAT, EARLY 1900S. Horses pulled this fishing boat float, the *Eagle*, in the 17th of May parade in Ballard. As Norway began 17th of May celebrations in 1836 and children's parades in 1870, Norwegian immigrants were not about to miss marking this day in their new home. (Courtesy Nordic Heritage Museum, 83.023.002z.)

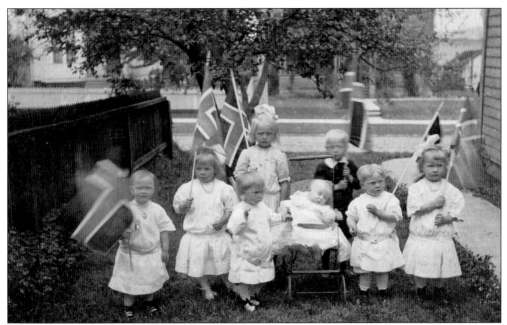

CHILDREN CELEBRATING THE 17TH OF MAY, EARLY 1900S. It is a safe bet the parents of these children posed them for a 17th of May photograph. In the early days of celebrating the 17th of May, Norwegian political leaders declared that the day should be about the children, to separate it from political tension, hence the 17th of May parades of schoolchildren in Norway to this day. (Courtesy Nordic Heritage Museum, 83.023.002bb.)

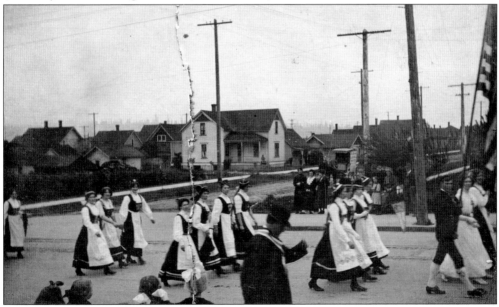

PARADE, EARLY 1900S. In an early 17th of May parade in Ballard, the route wound through a relatively undeveloped neighborhood. Today in Ballard, the day goes by several names: *Syttende Mai*, the 17th of May, or Norwegian Constitution Day. Although people assume it marks Norway's independence, the celebration actually marks Norway's first constitution. (Courtesy Nordic Heritage Museum, 83.023.002b.)

BEACON TO THE COMMUNITY, C. 1915. The Norwegian-Danish Baptist Church was organized in 1889 with 37 Scandinavian members. It was later named the Stewart Street Baptist Church before the congregation disbanded and the building was torn down. The pastor for 37 years was the Reverend Anders Mehus. (Courtesy University of Washington Libraries, Special Collections, UW 12075.)

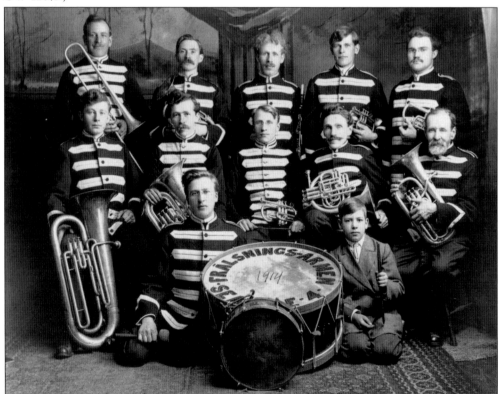

SALVATION ARMY BAND, 1914. The Salvation Army started in England in the mid-19th century and spread to other countries. Preaching the Gospel to the poor, the hungry, the homeless, and the destitute resonated with the cooperative spirit of Norwegians. In Norwegian it was *Frålsningsarmen*, which is evident on the drum of the band from Temple No. 4 in downtown Seattle. Temple No. 5 in Greenwood has maintained its ties to Seattle's Norwegian community. (Courtesy University of Washington Libraries, Special Collections, UW 27733.)

PASTOR J. T. NORBY, C. 1907. Johan Torvald Norby emigrated from Norway in 1887 and served churches in the Northwest. In 1938, he became the superintendent of the Seattle Seaman's Mission, a charitable institution sponsored by the Lutheran Church. He built the altar on display in the Norway Room of the Nordic Heritage Museum and was president of the Pacific Singers Association for several years. (Courtesy Volly Grande and Barbara Grande Dougherty.)

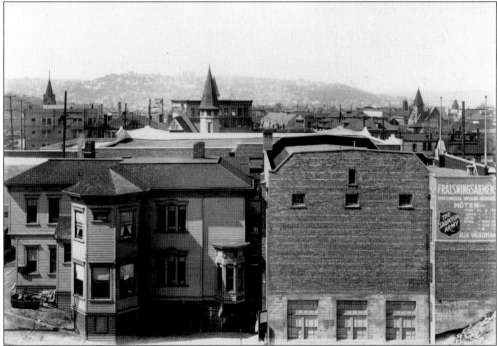

NORWEGIAN DANISH METHODIST, 1908. The church with the steeple in the background at 1900 Boren Avenue welcomed immigrants and supported them as they became accustomed to American life. It became the Central Methodist Church and later the Monastery, a drug-fueled disco club, before it was demolished in 1999. In the right foreground is the Norwegian Salvation Army (or *Frålsningsarmen*), with its meeting times painted on the building. (Courtesy University of Washington Libraries, Special Collections, Hester 11084.)

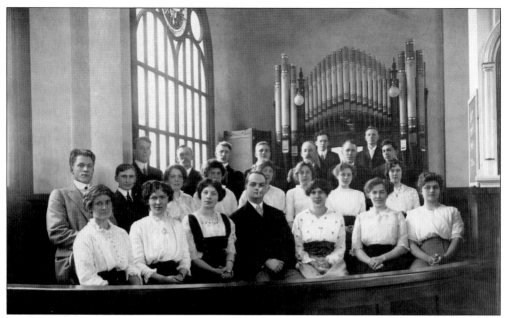

IMMANUEL LUTHERAN CHURCH CHOIR, 1914. Immanuel was a spiritual and social refuge for Norwegian immigrants. Most were young, and churches such as Immanuel were youthful churches. Funds for the pipe organ were raised by a challenge grant for $1,000 from the Andrew Carnegie Corporation if the church could raise the same amount. Eventually, the church grew to a congregation of up to 700 worshippers on holidays. (Courtesy Anne Marie Steiner.)

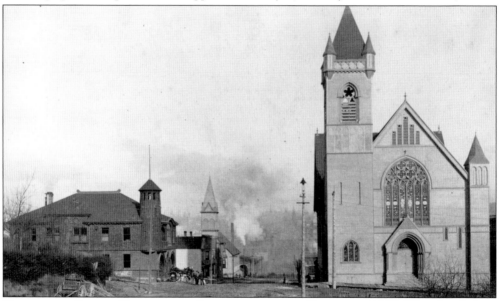

NORWEGIAN DANISH EVANGELICAL LUTHERAN IN THE DISTANCE, 1895. The church later changed its name to Denny Park Lutheran. The First Methodist Protestant Church is at Third Avenue and Pine Street, and Denny Park Lutheran's first church was at Fourth Avenue and Pine Street. A Norwegian society—*Fremad*—was part of the ministry of Denny Park from the beginning, with parties and services in Norwegian. (Courtesy University of Washington Libraries, Special Collections, Warner 3027.)

WEDDING DAY, 1915. Single young Norwegians flocked to Immanuel Lutheran Church, and marriages among parishioners were fairly common. Inga Humlebeck and Frode Frodesen met on a ship as they were each traveling back to Norway to visit family. They married and became prominent members of Seattle's Norwegian community. He made his mark on the building industry, and she was hailed at the "Mother of Norse Home." (Courtesy Anne Marie Steiner.)

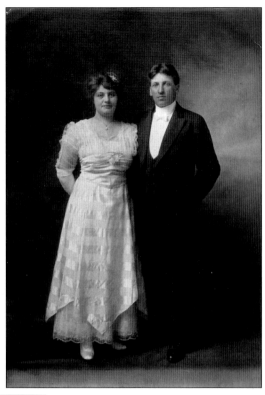

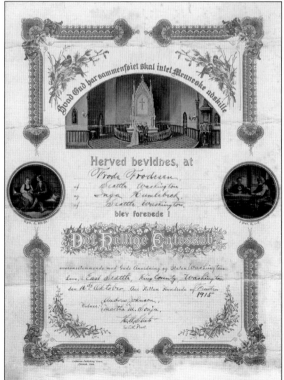

NORWEGIAN WEDDING CERTIFICATE, 1915. Immanuel Lutheran was founded by Norwegians, and Inga and Frode Frodesen's wedding certificate is in Norwegian. When the cornerstone was laid in 1912, a local Norwegian newspaper was included along with copies of the New Testament, Luther's Catechism, and other documents. Immanuel continued to have services in Norwegian until 1934, when they were discontinued except for special occasions. (Courtesy Anne Marie Steiner.)

FARM IN THE CITY, 1910. Ole and Anna Moen sold the fruit and vegetables they raised in the backyard of this house at 6513 Northwest Thirty-second Avenue in Ballard. It now houses the great-grandson and the great-great-grandchildren of the home's former owner Ole Moen. From left to right are Laura Brekke, an unidentified child, Ole Moen, Edward Nolan, and Edward Morris. (Courtesy Museum of History and Industry, 1980.6880.3.)

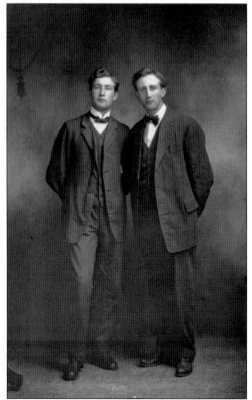

CHANGING NAMES IN AMERICA, C. 1911. Leif Olsson (right) emigrated from Norway and then returned several years later to bring his brother Knut (left) over. Leif said that with the last name Olsson he had often been mistaken for a Swede, and being called "a dumb Swede" was the worst insult. So they selected the name Berger—perhaps to blur their ethnicity—and Knut further refined his name to Knute. (Courtesy of Knute's grandson, Knute Berger.)

SISTERS, 1912. Laura Christoffersen and her daughter Lillian, along with Laura's sister Gulla Anderson and her son Floyd, are pretending to be on an outing for a photographer. Laura immigrated first; Gulla followed her to Seattle and found work as a housekeeper. Later Gulla married her employer, Capt. Fred Anderson, and they had three sons. Photographs of immigrants were serious business and an effective way to show the folks at home how well they were doing. (Courtesy Margaret Anderson.)

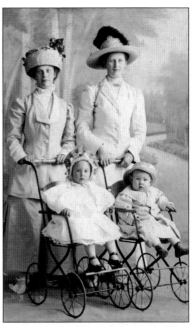

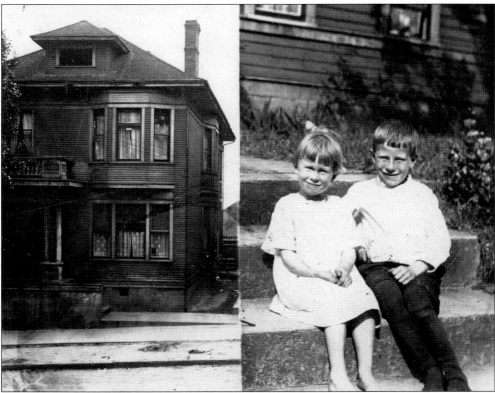

SISTER AND BROTHER, 1919. This is a postcard from the Gangmark family showing their children, Sigmund and Olive, and their home, near the present Swedish Cultural Center on Queen Anne Hill. Families often sent photograph postcards home to Norway to demonstrate their successes in America. (Courtesy Julie Svendsen.)

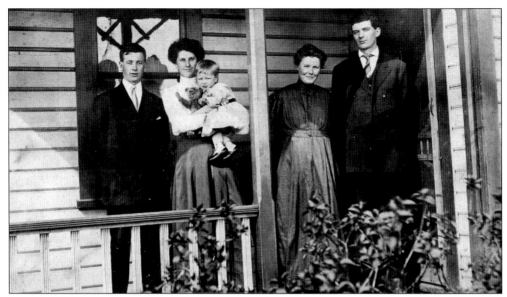

A NEIGHBORLY VISIT, 1909. Not all of Seattle's Norwegians lived in Ballard. Here, from left to right, Sverre and Julie Svendsen and their young son, Clarence, visit with neighbors on the front porch of the Svendsen home in Georgetown. He was a longshoreman and she was a housewife. After he passed away, she became the caretaker of Norway Hall and took in laundry and cleaned houses to make ends meet. (Courtesy Julie Svendsen.)

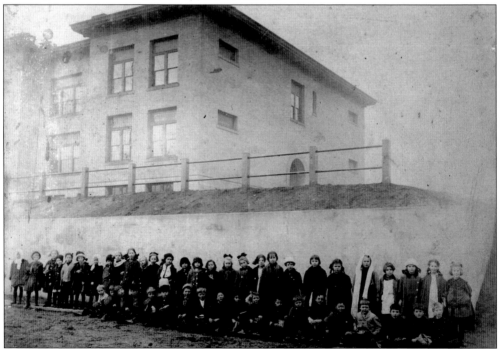

WEBSTER SCHOOL, 1907. Children pose in front of their new elementary school building. In the 1970s, the school was closed because of declining enrollment, and in 1980, the building was rented to the Nordic Heritage Museum. The Seattle School District plans to sell the building when the museum moves to its new location on Market Street. (Courtesy Lynn Moen.)

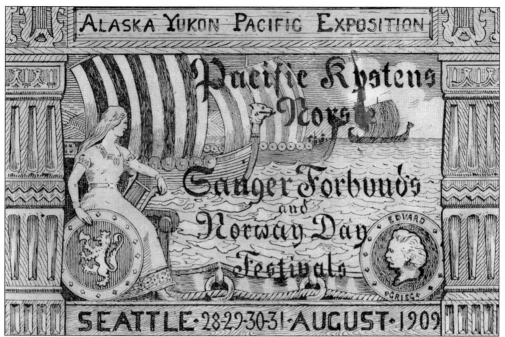

ALASKA YUKON PACIFIC EXPOSITION PROGRAM, 1909. Attendees called it "the AYP" and long remembered it. Norway Day was August 30, 1909, but the program cover indicates four days of celebration. It was similar to a world's fair, and as the city fathers hoped it would, the exposition drew people from across the country and even from abroad. (Courtesy Nordic Heritage Museum, 92.024.019.)

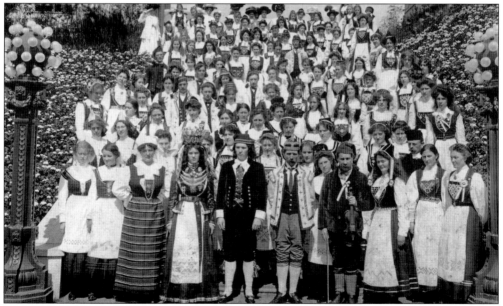

NATIONAL COSTUMES AT THE AYP, 1909. Several of the Scandinavian countries are represented by the attire in this photograph, but the majority of costumes are from Norway, with a plethora of Hardanger *bunad* dresses. A bridal couple poses with their fiddler for a mock wedding, one of the highlights of Norway Day, at the AYP. (Courtesy Nordic Heritage Museum, 83.023.002a.)

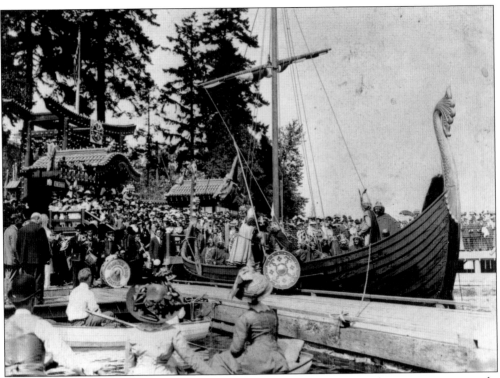

VIKING SHIP LANDS AT THE AYP, 1909. The Viking ship lands at the exposition grounds, which became the University of Washington main campus. Although history records report that the ship was to be met by Native Americans, none are evident in this photograph. The boat included a sea-serpent prow and tail on the stern. (Courtesy Museum of History and Industry, SH51575.)

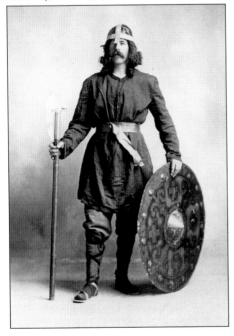

SEA KING, 1909. This man may be Erik L. Thomie, who played the part of the Viking king on the ship that landed on August 30. The program called for the ship to be sighted at 11:00 a.m. After cruising around the bay, it would cast anchor, and then Thomie and his queen, Astri Udness, would come ashore, along with their attendants. (Courtesy Museum of History and Industry, SHS 15048.)

NECKLACES FROM THE AYP, C. 1912. Ballard fisherman Chris Nelson loved to shower his two oldest daughters, Inga and Julia, with jewelry. Here the girls are thought to be wearing necklaces he bought at the AYP, each containing a gold nugget from Alaska. Many local families still have treasures in their homes from their parents' or grandparents' visits to the AYP. (Courtesy Gordon Strand.)

GRIEG SCULPTOR FINN HAAKON FROLICH, C. 1920. Frolich created the bust of composer Edvard Grieg unveiled on Norway Day at the AYP. In 1908, he was also a founder of an artists' colony, the Society of Beaux Arts, on the eastern shore of Lake Washington, where he and two others imagined artists living, working, and playing together. This community celebrates its centennial in 2008 and is still a separate municipality. (Courtesy Nordic Heritage Museum.)

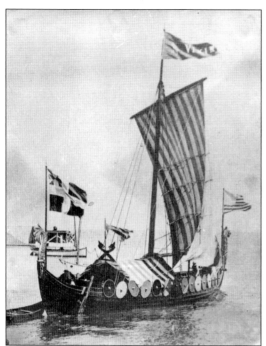

VIKING SHIP IN FULL REGALIA, 1909. On Norway Day at the AYP, a "Viking king and queen" sailed down Lake Washington and came ashore. Norwegian king Haakon VII sent his greetings, the St. Olav band played, and a parade float honored Ibsen. This event is said to have inspired the Leif Erikson Day celebrations that continue in Seattle today. (Courtesy Alice Sagstad.)

VIKING SHIP DETAIL, 1908. Sivert Sagstad, owner of the Ballard Boat Works, built this ship in conjunction with the Bothell Lodge of the Sons of Norway. It was reported to be an exact replica of a Viking ship. The location was handy, as there was no connection yet from Shilshole Bay to the lake, and the ship could be sailed down the slough to Lake Washington and the AYP site. (Courtesy Alice Sagstad.)

Two

FROM WAR TO WAR
EARLY 1920S TO LATE 1940S

By 1920, every 20th inhabitant of Seattle was Norwegian-born or the offspring of Norwegian parents. In Seattle, one could shop, work, worship, and socialize in the Norwegian language. Ballard became a Norwegian community where one could meet or perhaps marry a neighbor from home—or at least talk to someone who spoke the same dialect. Even so, the end of World War I brought a lack of tolerance for foreigners, and there was a push to fit in and become "real Americans."

This was the era of polar exploration, and many of the explorers were Norwegian. Thousands came out to see Roald Amundsen or followed the adventures of Fridtjof Nansen. It was also a period when the country was weary of war and looked for heroes, even father figures. Perhaps the search for heroes was influenced by the growing national media. Whatever the reason, heroes and other strong individuals were important to the Norwegian community.

Men worked hard, and so did women. Norwegians accepted the toil and physical danger of logging and fishing. Some were able to buy luxuries such as automobiles and furs; those with money could afford to visit Norway. The clubs became more formal, with uniforms, regalia, pomp, and circumstance. Rather than simply going to church together, which they still did, they also developed drill teams and banners, bronze plaques, and beautiful program covers.

This period ends with World War II, or *Krigen* ("The War" as it was called in Norwegian). Many joined up and fought in American forces; everyone sacrificed. Even with limited communication, news from Norway leaked to America. Many here sent food, clothing, and money to their extended families in Norway. Everyone yearned for wartime to end. And fortunately, it did.

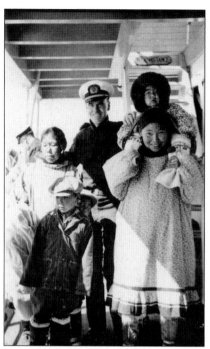

THE *NORTH STAR*'S CAPTAIN IN ALASKA, 1935.
Capt. Isak Kristian Tonder Lystad from Norway was the captain of the *North Star*, a supply ship that ran from Seattle to as far north as Barrow, Alaska, for the U.S. Bureau of Indian Affairs. She often docked at Pier 91 or the Ballard Locks. Captain Lystad is shown here on an Arctic supply run with a group of native Alaskans. (Courtesy Rolf Lystad.)

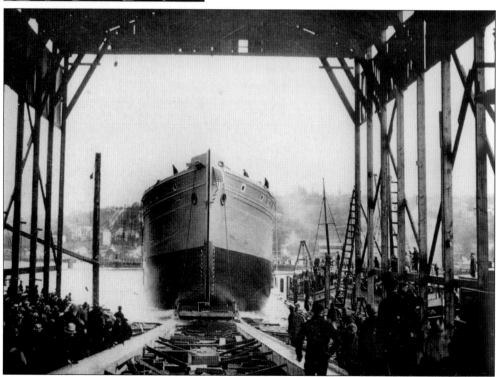

LAUNCH OF THE *NORTH STAR*, 1932. Perhaps Seattle's most famous ship was the *North Star*, a wooden icebreaker built by Ballard's Berg Shipbuilding for the U.S. Bureau of Indian Affairs. Adm. Richard E. Byrd used the ship in his polar explorations of the Antarctic in 1939–1941. She is being launched here into Salmon Bay on January 18, 1932. (Courtesy Rolf Lystad.)

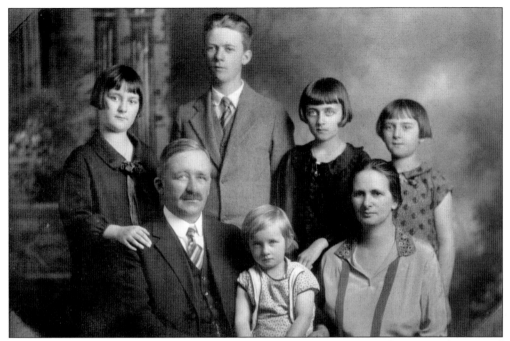

THE AMERICAN DREAM, 1930. Combining a Norwegian naval architecture degree and American hard work, shipbuilder Ingvald Heggem achieved the life that many immigrants hoped for. The family was active in the Ballard First Lutheran Church, and the children became Pacific Lutheran University–educated professionals. This is their passport photograph. From left to right are (seated) Ingvald, Lillian, and Marit; (standing) Mabel, Olaf, Catherine, and Margaret. Ingvald entered America through Canada; immigration officials required him to denounce King George, although he had never set foot in England. (Courtesy Julie Pheasant Albright.)

CAPT. LOUIS LARSEN, C. 1938. Norwegian-born Louis Larsen (right) was the captain of a fishing boat, the *Summit*, which mysteriously blew up off Vancouver Island in 1945. He and his men were among the first names installed on the Fishermen's Memorial dedicated in 1988 to honor those who lost their lives at sea. (Courtesy Glory Frodesen.)

ALBERT SANDAAS, ANOTHER KIND OF BUILDER, 1922. For every Norwegian architect or contractor, many others were limited by economic or family issues. Albert Sandaas immigrated as a child. Though he overcame much adversity, he did not achieve his goal to be an architect. Working as a plant engineer at Ford and Boeing, he found pleasure in designing his own home. And like other Norwegians, he also made sure his children were college educated. (Courtesy the Sandaas family.)

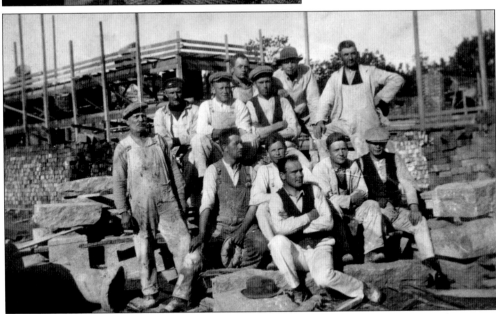

CONSTRUCTION WORKERS, C. 1928. Advice to immigrants persisted along these lines, from Theodore Christian Blegen: "The person who neither can nor will work must never expect that luxurious living will be open to him. No, in America, one gets nothing without work; but it is true that by work one can expect to achieve better circumstances." Given that most of them came because they were poor, Norwegian immigrants readily adjusted to the hard work of building a new community. (Courtesy Sissel Peterson.)

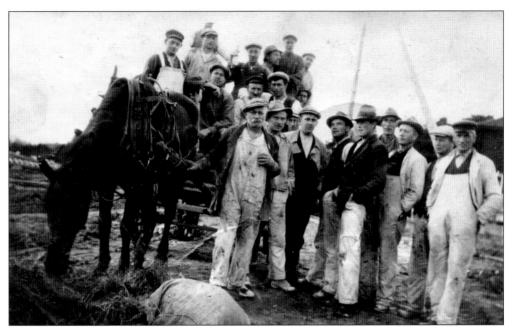

ON THE FARM, C. 1928. Not all immigrant Norwegians turned to fishing, boatbuilding, or construction. Many either were harnessed full time to agriculture or supplemented their city income by working on farms in nearby Skagit, Snohomish, or Thurston Counties, particularly during harvest or for a year or two at a time. These workers are taking a break, probably from working a field in Snohomish County. (Courtesy Sissel Peterson.)

FROM SHOEMAKER TO MILLIONAIRE, 1935. Born in Bergen, Karsten Solheim immigrated as a young boy with his family to Seattle. He started as a shoemaker, like his father, but eventually moved to General Electric. He became a millionaire after inventing a golf putter under the brand name of Ping and establishing the Karsten Manufacturing Company. (Courtesy Nordic Heritage Museum, 1999.056.001.)

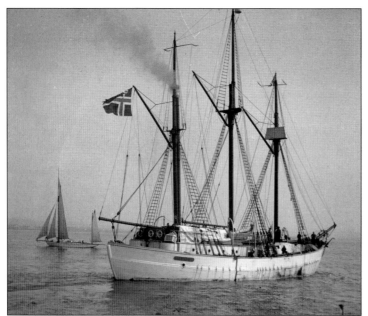

ROALD AMUNDSEN'S *MAUD*, **1921.** Roald Amundsen was the first explorer to reach the South Pole, but he loved the Arctic. He designed his schooner *Maud* and set off from Norway in 1918 to explore the area near the North Pole. The ship spent its first two winters frozen in Arctic ice. In 1921, it came to Seattle for repairs before sailing back to the Arctic. (Courtesy Museum of History and Industry, *Seattle Post-Intelligencer* Collection, PI 26060.)

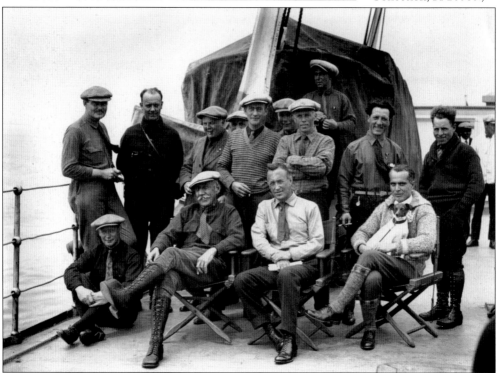

AMUNDSEN AND HIS DIRIGIBLE CREW, 1926. In June 1926, sixteen men crossed the North Pole from Norway to Alaska in the airship *Norge*. Explorers Roald Amundsen (seated, left) and Lincoln Ellsworth (seated, center) led the trip, and Umberto Nobile (seated, right) piloted the dirigible, which is behind them. On their way back, they stopped in Seattle. More than 5,000 cheering people greeted them. (Courtesy Museum of History and Industry, Pemco Webster and Stevens Collection, 83.10.847.)

UNCLE SVEN ALWAYS BROUGHT ICE CREAM, 1939. Sven Nilsen from Karmøy was a seaman on the Matson Line and never married or had a car. His niece remembers that when he came to visit by streetcar, the children all waited anxiously for him because he always brought hand-packed ice cream, and when he visited, they always had *kumla* (potato dumplings). (Courtesy Margaret Anderson.)

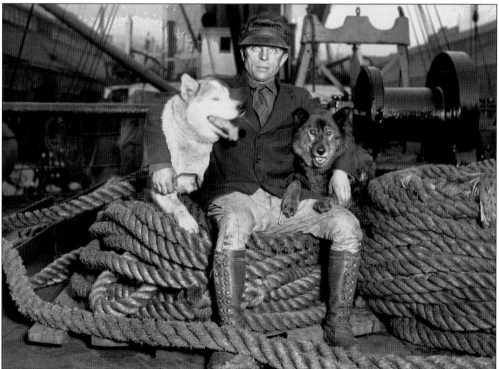

DOG-MUSHER, C. 1926. Leonard Seppala left northern Norway to pan for gold in Alaska and instead became a famous racer. When Nome was experiencing a diphtheria epidemic in 1925, Seppala and his lead dog, Togo (the black dog), successfully carried the serum 91 miles in minus-30-degree temperatures. He retired to Ballard in 1946. A monument honors him in Skibotn, Norway, a statue in Central Park honors Togo, and a bloodline of Siberian huskies is called Seppalas. (Courtesy Museum of History and Industry, 1986.5G.2757.)

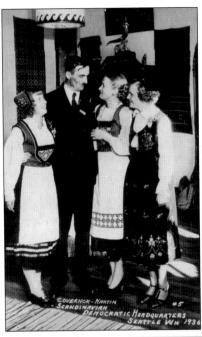

GOV. CLARENCE MARTIN AT THE SCANDINAVIAN DEMOCRATIC HEADQUARTERS, 1936. Some politicians worked to align local and national candidates in the Democratic Party with the Scandinavian American community. Pres. Franklin D. Roosevelt was compared to a Viking chieftain, and interested people were invited to visit the "Hall of the Vikings" at the Scandinavian Democratic headquarters, located at 1910 1/2 Fourth Avenue in Seattle. Eighteen-year-old Christine Larsen from Ballard is on the right. (Courtesy Glory Frodesen.)

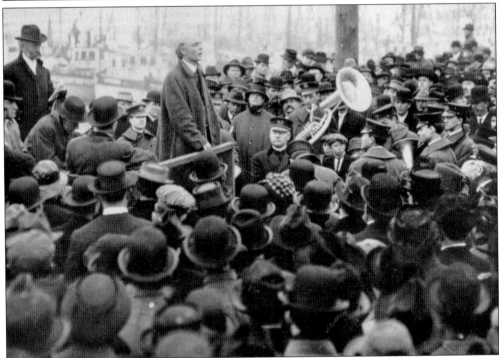

NORWEGIAN MAYOR OLE HANSON, 1920S. Hanson was mayor of Seattle in 1919, when local unions went out on a large general strike and shut the city down for three days. The strike ended quickly and peacefully. The war-weary nation was ready for heroes, so the media gave Hanson credit. He was catapulted into a brief moment of fame. But after an electoral defeat, he moved to California and founded the town of San Clemente. (Courtesy Nordic Heritage Museum, 1999.060.088.)

SAILING TO AMERICA, 1924. Sofie Esvik (third row, sixth from left) left her home in Rissa at the age of 19 and immigrated alone because she "didn't want to be on the farm picking rocks any more." She traveled to Canada on the RMS *Antonia* of the Cunard Line, and a few years later, she married her childhood sweetheart, who was living in Seattle. (Courtesy Sonja Beck.)

COMING HOME FROM NORWAY, 1935. From left to right are an unidentified man; Louie Holm holding his son, Eldred; Holm's daughter, Sylvia; and Louise Holm. Fishing was good in the 1930s, and the Holms could afford a trip to Norway, where they bought furs. Louie Holm continued to be a successful fisherman but lost his life when his boat disappeared during World War II, probably the result of a Japanese mine. (Courtesy Margaret Anderson.)

SEATTLE SEAMEN'S HOME, 1922. Lay people and pastors began a ship visitation ministry among Norwegian and other Scandinavian seamen in 1889. The Lutheran Church found a home for these endeavors in this building, convenient to the waterfront, in 1917. Here the headquarters at 88 Marion Street included both a mission and a hotel for many a storm-tossed man. A sign in the window advertises "Café Viking—Home Cooking—Waffles Coffee 25¢." (Courtesy Museum of History and Industry, Webster and Stevens Collection, 1983.10.2337)

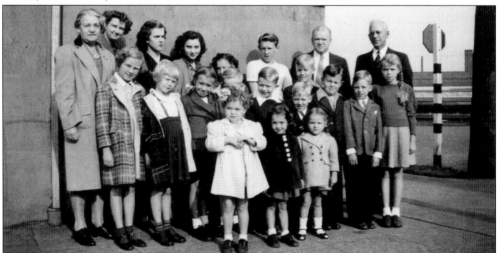

NORWEGIAN-DANISH BAPTIST CHURCH, c. 1944. The Sunday school of the Norwegian-Danish Baptist Church poses for a photograph. In the third row are the pastor's wife, Marie Mehus (left), Albert Sandaas (second from right), and Pastor Anders Mehus (far right). Albert's daughter, Vivian Sandaas, is in the first row on the right. The church was organized in 1889 and disbanded in 1959. (Courtesy Nordic Heritage Museum, 112.1997.167.3.)

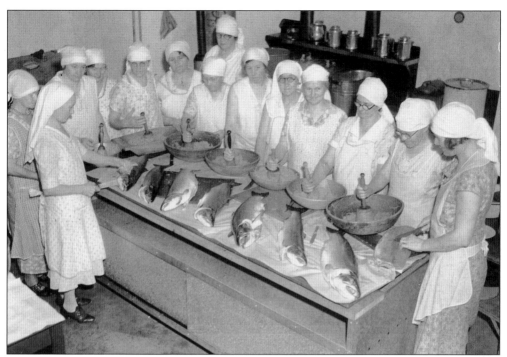

LADIES OF BALLARD FIRST LUTHERAN, 1930. The Ladies Aid members are preparing cod cakes. In this earlier era, women were sometimes identified only by their last names or their husbands' names. From left to right around the counter are Mrs. C. Glaso, Mrs. Tom Olson, Mrs. Ed Peterson, a Mrs. Kodal, a second Mrs. Ed Peterson, a Mrs. Christiansen, a Mrs. Chriss, Mrs. Anton Anderson, a Mrs. Stokke, a Mrs. Robeck, Mrs. Eilert Erikson, Mrs. Ingvald Heggem, a Mrs. Mathiesen, and Mrs. Olga Linvog. (Courtesy Nordic Heritage Museum, 81.091.003.)

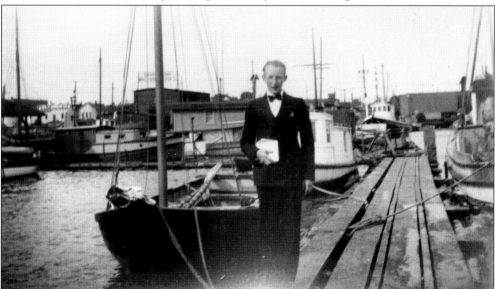

CONFIRMATION IN BALLARD, 1935. Fred Anderson is holding a present he was given for his confirmation. His family lived in a boathouse, so walking the docks in his best suit was a normal thing. (Courtesy Margaret Anderson.)

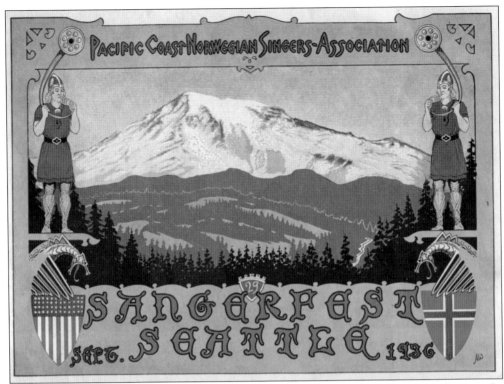

SANGERFEST PROGRAM, 1936. In Norway, singing was an important source of music for ordinary people because anyone could sing without owning a fiddle or an accordion. When the immigrants began arriving, they brought with them a long history of men's and women's choruses and eventually started similar groups here. Seattle's Norwegian Male Chorus was organized in 1889. The Sangerfest signing festival is for Norwegian men's choruses along the Pacific Coast. (Courtesy Nordic Heritage Museum.)

SVERRE ARESTAD. On the faculty of the University of Washington from 1934 until 1972, Arestad's primary field was Norwegian language and literature, particularly the work of Ibsen. He also did research and published on the history of Scandinavian immigration to the Northwest. He was extremely popular with his students. Twenty years after his death, one of his students anonymously endowed a chair in his name. (Courtesy Scandinavian Studies Department, University of Washington.)

BRONZE PLAQUE OF LEIF ERIKSON, 1930S. August Werner was a talented singer and artist, and a popular member of Seattle's Norwegian American community. He created this plaque for the Leif Ericson Park in Brooklyn, New York. A similar version in wood hangs in the Leif Erikson Lodge of the Sons of Norway. Leiv Eiriksson is the Norwegian spelling; Leif Ericson is more commonly used on the East Coast and Leif Erikson on the West Coast. (Courtesy the author's collection.)

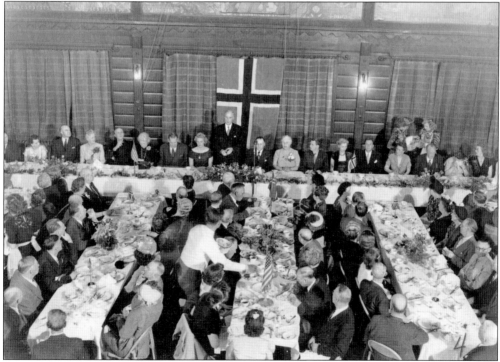

DINNER AT NORWAY HALL, C. 1945. As soon as there was a building, there were dinners. This one may have been for the 17th of May or Leif Erikson Day, held on October 9th. Guests at the head table include Norwegian consul Christian Stang, Gertrude and August Werner, and Inga and Frode Frodesen. Note the murals over their heads, which were moved from this building to the Norway Center and later to the Leif Erikson Lodge. (Courtesy Anne Marie Steiner.)

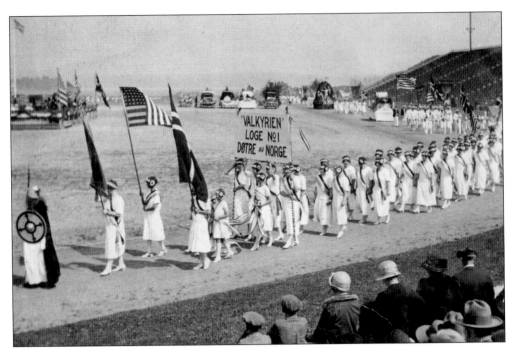

NORWEGIAN CENTENNIAL CELEBRATION, 1925. A large Norse American Centennial was held in 1925 to mark the 100th anniversary of the sailing of the ship *Restauration* into New York Harbor and the beginning of Norwegian emigration. Valkyrien Lodge of the Daughters of Norway, founded in 1905, is marching where Husky Stadium would later be built. Similar celebrations were held in other Norwegian American communities across the country. In the photograph below, Julie Svendsen, president of Valkyrien Lodge, is leading the group. She was known for her long, flowing, dark hair. (Courtesy Julie's granddaughter, Julie Svendsen.)

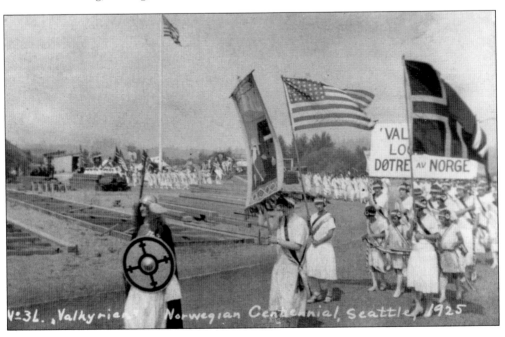

17TH OF MAY AT SEATTLE'S CIVIC AUDITORIUM, 1928. From left to right are (first row) two unidentified; (second row) Anne Marie Frodesen, Jan Helge "John" Frodesen, and Sissel Almaas; (third row) John Gorud. In those days, the parade wound around the inside of the building and ended up onstage for singing and a patriotic Norwegian program. (Courtesy Anne Marie Steiner.)

CONSULATE GROVE, 1932. Thirty-five countries planted trees at the University of Washington to celebrate the bicentennial of George Washington's birth. Each consulate planted a native tree from their country. Norwegian consul Thomas Hungtington Kolderup planted a birch tree. Kolderup was the uncle of later consul Christian Stang. The only trees that now exist are oaks, so in 2009, the Scandinavian Studies Department planned to plant eight oak trees to represent each of the Nordic and Baltic countries. (Courtesy University of Washington Libraries, Special Collections, 20023.)

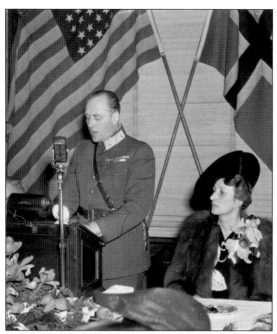

THE ROYAL COUPLE VISIT THE SEATTLE CHAMBER OF COMMERCE, 1939. In the buildup to World War II, Crown Prince Olav V and Princess Märtha toured America to gain support for Norway. When Prince Olav spoke, he wanted her near enough so that she could take part. He was careful to include her with the phrase, "The Crown Princess and I." He reigned from 1957 to 1991. Both were immensely popular with the people. (Courtesy Museum of History and Industry, *Seattle Post-Intelligencer* Collection, 1986.S.37786.)

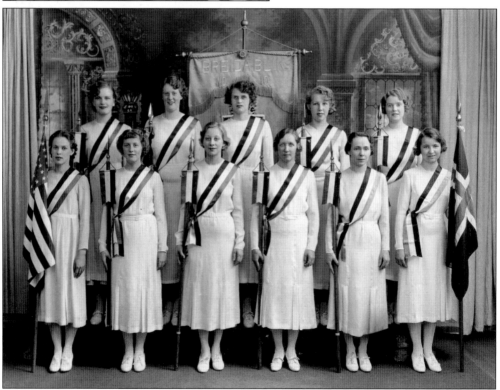

DAUGHTERS OF NORWAY DRILL TEAM, C. 1938. Organized in Ballard in 1910, the Breidablik Lodge had 150 members at its height. A *Seattle Times* article about its closing in 2003 reported that Mabel Torget joined Breidablik on May 17, 1938, because she wanted to be on the drill team, which, incidentally, carried broomsticks. (Courtesy Glory Frodesen.)

EXHIBIT AT NORWEGIAN HOSPITAL ASSOCIATION PICNIC, 1924. Mrs. Gunnar Lund (left), editor of the association newsletter, and Mrs. Reidar Gjolme, past president, are exhibiting items at an event in Seattle on September 7, 1924, one year after the hospital began operating. Just as the Sons of Norway was started to provide insurance and death benefits to immigrant Norwegians, the Norwegian Hospital Association was created in 1913 to serve their health care needs. (Courtesy Anne Marie Steiner.)

NORWEGIAN HOSPITAL, 1923. Helping one another was an important goal in Norwegian culture. The mission of the hospital was to serve immigrants, who were flooding into the area. Located between Woodland Park and Lake Union, it operated for only three years, but the association continued its work and was instrumental in the establishment and support of the Norse Home. (Courtesy Nordic Heritage Museum, 1999.060.072.)

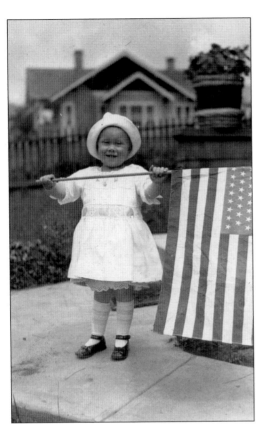

"EVERYONE WANTS TO BE AMERICAN."
Anti-immigrant feelings were strong in
America in the post–World War I era.
Immigrants tried to assimilate as quickly as
possible, and being called out as Norwegian
or Swedish was an insult. Margaret
Haines, at left, the daughter of Norwegian
immigrants living at 5808 Fifth Avenue
NW in Ballard, waves a flag in 1920. In
spite of her parents' ultra-American dreams,
she grew up to be an active member of the
Sons of Norway. Clarence Svendsen, below,
was about seven years of age in this 1915
photograph. He followed in his family's
strong musical tradition and was a longtime
member and supporter of the Norwegian
Male Chorus. (Left, courtesy Margaret
Anderson; below, courtesy Julie Svendsen.)

SISTERS, C. 1920. These are the girls pictured in Chapter One with gold nugget necklaces from the AYP. Here Inga (left) and Julia Nelson demonstrate the closeness they felt all their lives. Both dropped out of school when their father died and both married fishermen, just as their mother had done. Julia's given name was Julie, but when she started school in Ballard, her Norwegian mother pronounced it "U-lee-a," so the Adams School registered her as Julia. (Courtesy Gordon Strand.)

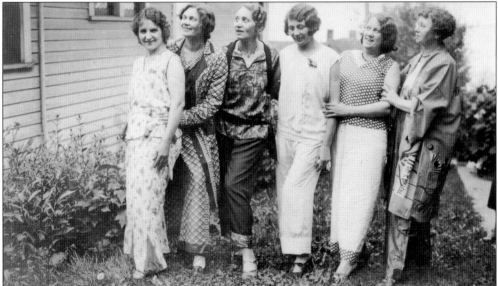

BEACH PAJAMAS, 1920S. These young Norwegian women would not be left behind in fashion! Wide-legged, two-piece, loose beach pajamas marked a turning point in women's clothing and introduced more casual clothes for fun times. These women are showing off their beach pajamas for a birthday party. Caroline Rolie (second from left) and Edna Pedersen (third from left) are included in the group. (Courtesy Lynn Moen.)

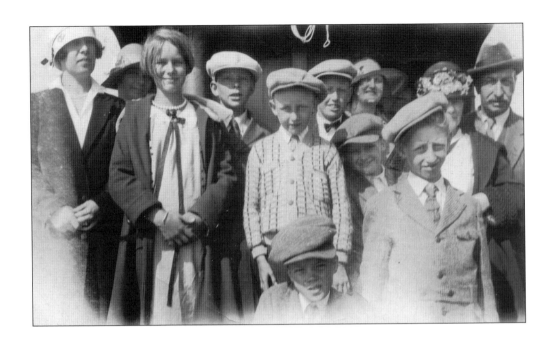

FAMILY PICNIC, 1926. Everyone dressed up for picnics, even if moments later they were diving off the edge of the boathouse. Capt. Fred and Gulla Anderson's family are pictured here. Margaret Anderson remembers that they wore American sweaters and not Norwegian sweaters, until the late 1930s or early 1940s, in an effort to fit in and not look like immigrants. In the photograph below, they are diving off the boathouse, which was at the foot of Twentieth Avenue in Ballard. The fact that wastewater and sewer lines ran into the same water did not seem to bother anyone. (Both, courtesy Margaret Anderson.)

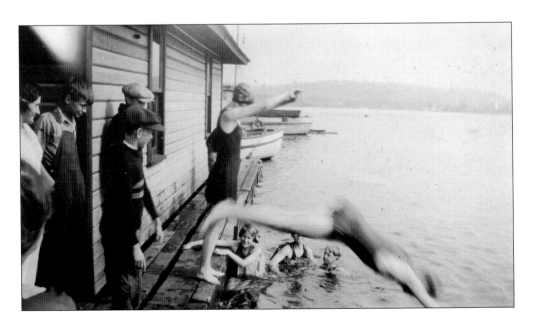

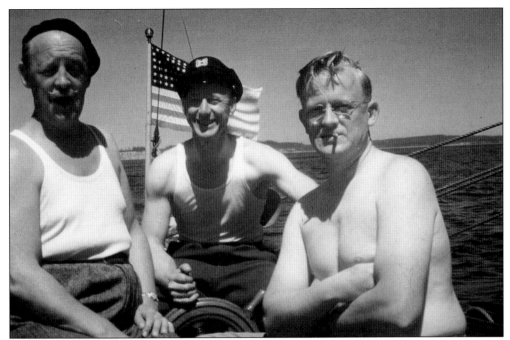

AUGUST WERNER, C. 1941. Professor Werner (left) was a beloved member of the Norwegian American community. Although he emigrated from Bergen as a seaman, his first job in Seattle was as a soloist for the Norwegian Male Chorus. He was asked to sing at the University of Washington commencement, which led to a faculty position. He directed the Norwegian Male Chorus and founded the women's chorus. Here he is on a boat enjoying Puget Sound with Clarence Svendsen (center) and Jerry Sandvig (right). A baritone, he often spontaneously burst into song. (Courtesy Julie Svendsen.)

PICNIC AT WOODLAND PARK, 1921. Norwegians loved their picnics and getting out into nature. From left to right, John, Karin, and daughter Margaret Haines are gathered with friends at Woodland Park. Sunday was often the favorite day for picnics. Margaret remembers, "We always loved just being together." (Courtesy Margaret Anderson.)

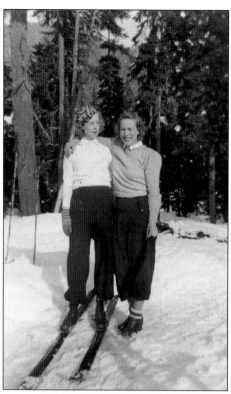

SKIING AT SNOQUALMIE PASS, C. 1930. Olive Gangmark (left) and her cousin Margaret Gangmark enjoyed skiing. Because there was no ski lift and they had only one pair of skis, they took turns. One would hike up the slope in the morning and ski down, and the other would hike up and ski down in the afternoon. Then they would drive home. (Courtesy Julie Svendsen.)

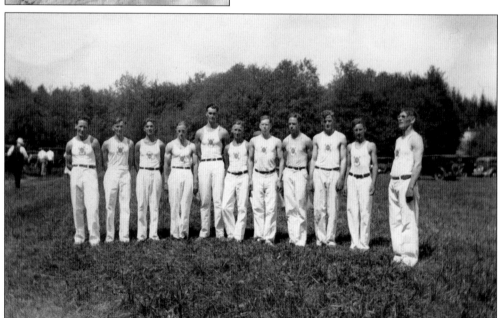

TURNER SOCIETY, C. 1928. This gymnastic society, with the philosophy of "a sound body and a sound mind," was appealing to Norwegians. In spite of its German American origins, many Norwegian men were committed to the Turner Society's ideals of athletic form and social liberalism. The society also had balls and social gatherings. Arne Tvete is the first man on the left, Wayne Sessions is the third, and Ragnar Svendsen is the fifth. (Courtesy Julie Svendsen.)

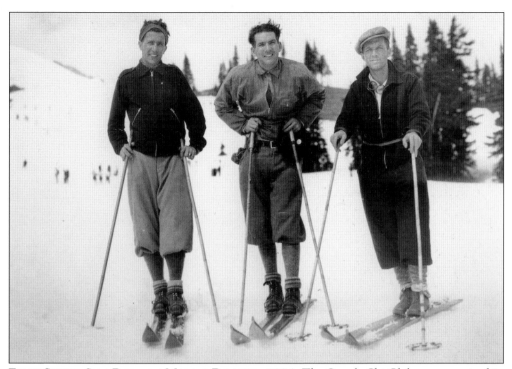

FIRST SILVER SKIS RACE ON MOUNT RAINIER, 1934. The Seattle Ski Club was organized in 1928 by first-generation Norwegians to promote skiing in the Northwest. From left to right, members Don Fraser, Alf Moystad, and Hans Otto Giese raced in this first, most daring race on Mount Rainier in 1934. Sixty skiers hiked up to Camp Muir, lined up one yard apart, and with a simultaneous start, raced four miles down to Paradise. It was America's wildest ski race, both elegant and insane, and put the Northwest on the map for skiing. The photograph below shows the ending of the 1936 race. Just days before Hitler invaded Norway in 1940, a champion Norwegian skier, Sigurd Hall (Hoel), was killed in the Silver Skis race. In 2006, forty-six years later, his extended family came from Norway, climbed Mount Rainier in his honor, and visited the spot where he died. (Above, courtesy Museum of History and Industry, *Seattle Post-Intelligencer* Collection, P126897; below, courtesy Nordic Heritage Museum.)

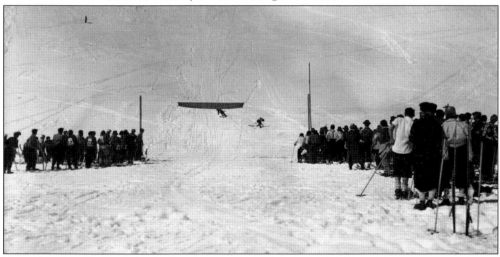

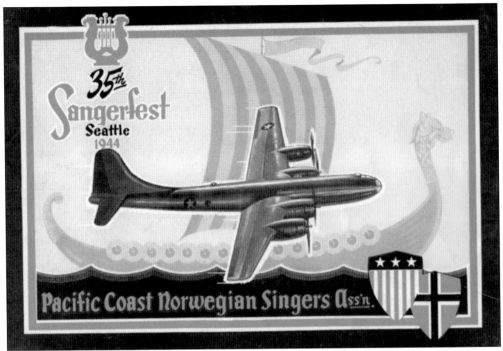

SANGERFEST DEVOTED TO THE EVENTS IN NORWAY, 1944. The cover of the 35th annual program paid tribute to the formidable Viking ship and Boeing's B-29 Superfortress bomber. Norway had been invaded and "As . . . they courageously fight . . . the aggressor, we in the midst of freedom . . . turn our prayers to Norway . . . in faith that the day will soon return when her people shall sing '*Ja, vi elsker dette landet*' as free men." (Courtesy Julie Svendsen.)

MILITARY MOTHER, 1945. Gulla Anderson's three sons all joined the military, and she was understandably proud of the flag with three stars in her window. Although she and her husband, Fred, had raised their sons in a boathouse, by this time, the boys were gone, and they lived on Sloop Street NW. Gulla (center) is shown with her sons, (from left to right) Floyd, Carl, and Fred. (Courtesy Margaret Anderson.)

CHRISTMAS IN WARTIME, 1945. One-year-old Glory Frodesen (right) wears shoes with the toes cut out to stretch their usability while her father serves in the military. At the Shriners' Christmas party at the Masonic Temple, Glory and her older sister, Janet (left), received bags of candy. (Courtesy Glory Frodesen.)

THE RIGHT PLACE AT THE RIGHT TIME, C. 1945. Knute Berger started a company during the Depression to design logging and engineering equipment and had a host of patents for his designs. He helped the war effort by developing a winch that was used by the military to get landing craft back into the water. His Berger winch went on to be widely used in commercial marine vessels. (Courtesy Knute's grandson, Knute Berger.)

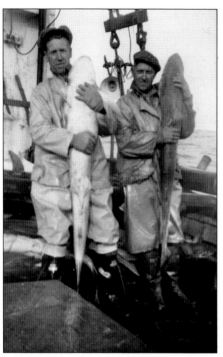

SHARK FISHING DURING THE WAR, 1944. Eiler Coien (left) was one of many fishermen who made it big during World War II fishing for shark. The oil was used as a lubricant in combat aircraft, and there was a substantial increase in demand. Eiler, who had immigrated from Rissa in 1927, funded his family's first trip back to Norway in 1947 thanks to the lucrative shark oil market. (Courtesy Sonja Beck.)

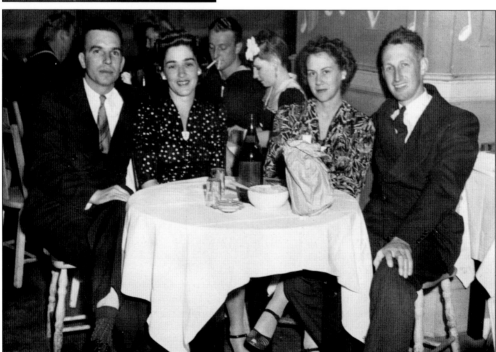

CELEBRATING THE RETURN FROM SERVICE, 1944. Margaret and Carl Anderson (right) are celebrating his discharge from military service in the South Pacific. Elmer Anderson and Lillian Ellingsen have joined them at the Trianon Ballroom in downtown Seattle. Note the bottle of whiskey in the bag. Margaret remembers that it was McNaughtons. (Courtesy Margaret Anderson.)

Three

FROM NORWAY CENTER TO NORDIC HERITAGE MUSEUM
1946 TO THE 1980S

After World War II, the U.S. government helped Norway with the Marshall Plan, and individuals and groups helped with Norwegian relief. Even so, in the few years after the war, jobs in Norway were scarce, and an influx of immigrants left there for better opportunities in America. A number of Norwegian fishermen came for fishing and crabbing, and engineers came to work at Boeing.

In the Northwest, jobs were available, especially in the building trades. Homes needed to be built for returning veterans, and the Norwegian American community planned and developed two major building projects, the Norway Center and the Norse Home. Many Norwegian carpenters fished in the summer and built homes in the winter.

Public presentations of Norwegian ethnicity were very visible. If the period following World War I brought the need to hide one's Scandinavian roots, the end of World War II brought the opportunity to strut them. There were organized, well-attended celebrations of Norwegian heritage at Christmastime and on the 17th of May and Leif Erikson Day.

Healthy cultures are always dynamic, and the Norwegian American culture in the Northwest was easily described as such during this period. From the Nordic Council came the Nordic Heritage Museum. The Bergen-Seattle Sister City relationship got started, and major gifts were exchanged. Norwegian and American students traded places. An icon of the community, the statue of Leif Erikson, was installed, the culmination of many years of work. Skiing became more recreational and popular, and Scandinavian restaurants opened up. It was, in many ways, a golden era in the Norwegian American community in Seattle.

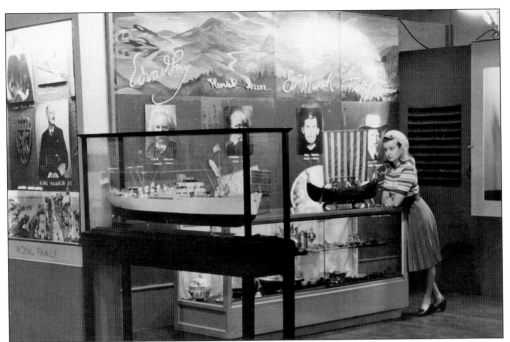

EXHIBITION TITLED NORWAY RESUMES PROGRESS, 1946. Norway's first trade exhibit ever in Seattle was right after the war. Export products and cultural items were featured at the Pacific Northwest Parade of Progress at the Washington State Armory. Local college students from Norway were guides. A skiff (below) that had been used by a group of Norwegian youths who sailed to Scotland to escape Nazis during the war was on display. Norway was proud of its effort to mount the exhibit, and Seattle was proud of its ability to host the event. (Both, courtesy Marilyn Whitted.)

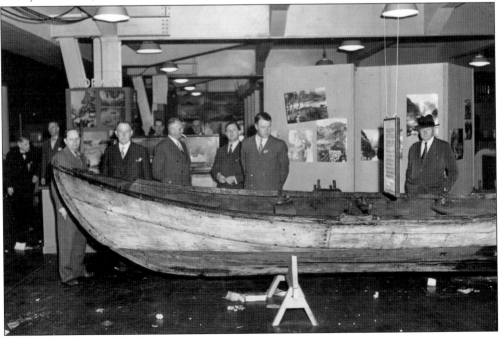

NORWEGIAN SEAMSTRESS, 1950.
Norwegian women since Viking times
have helped to support their families
when their men were away at sea. Gwen
Stryggen's mother, Vera, sewed for the
neighborhood for extra income; her
father, Omar, a fisherman, was gone
for much of the time. Here 17-year-old
Gwen is wearing a gown her mother
made. (Courtesy Glory Frodesen.)

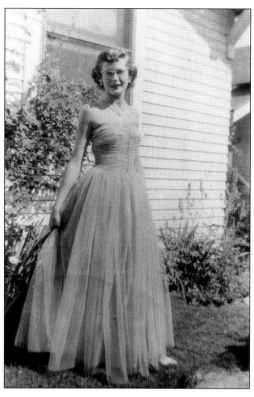

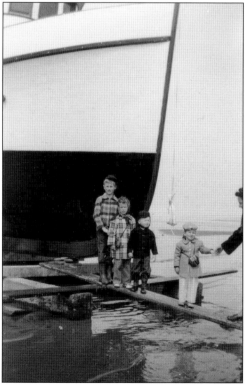

**LAUNCHING THE CAREFREE AT BALLARD
BEACH, 1949.** The name *Carefree* for
this salmon-and-tuna trawler came from
combining the Anderson brothers' first
names, Carl and Fred. Here, from left to right,
Carl's children, Norman and Craig, and their
cousins Sherry and Camille are helping with
the launch. (Courtesy Margaret Anderson.)

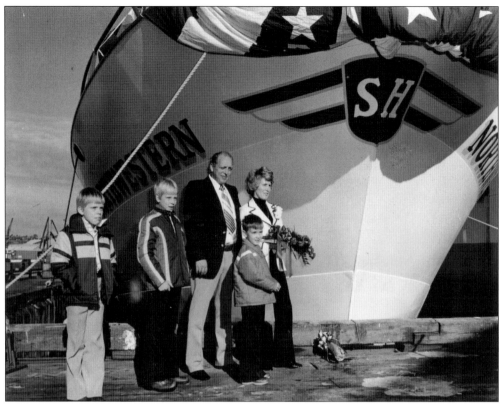

LAUNCH OF THE NORTHWESTERN, 1977. The *Northwestern* was built in 1977 at the Marco Shipyards in Magnolia and was lengthened as the maximum number of crab pots increased. Parents Sverre and Snefryd Hansen came to Seattle from Karmøy in the late 1950s. Their sons, (from left to right) Norman, Sig, and Edgar, went to work as fishermen when they were 14, first working on gillnetters in Bristol Bay. Oldest brother Sig is now the captain. He and the *Northwestern* are featured on the Discovery Channel series *The Deadliest Catch*. (Courtesy Sig Hansen.)

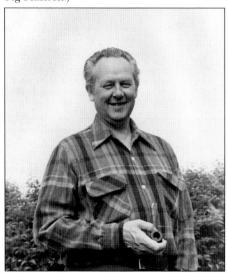

"PULL UP A CHAIR, OMER MITHUN," C. 1980. Architecture professor Omer Mithun, whose family came from Midtun, Norway, founded Mithun, Inc., offering architecture and landscape design services. Mithun, Inc., designed more buildings in Bellevue than any other firm. The company also designed the Port of Seattle offices at Shilshole Marina and the Ballard Public Library and will design the new Nordic Heritage Museum. Omer was so approachable that his biography was titled *Pull up a Chair*. (Courtesy Mithun, Inc.)

A MENDER OF NETS, 1956.
Peter Eide of Ballard learned net mending from his fisherman father in a community south of Narvik, Norway. At the age of 74, Eide was still mending nets for Seattle-area fishing boats, a craft that takes a lifetime to perfect. This photograph is by Josef Scaylea. (Courtesy Museum of History and Industry, 1993.20.213.)

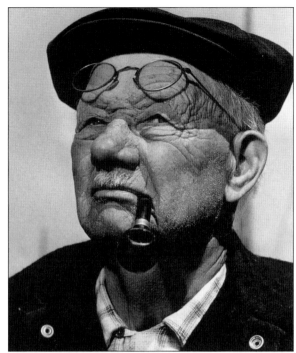

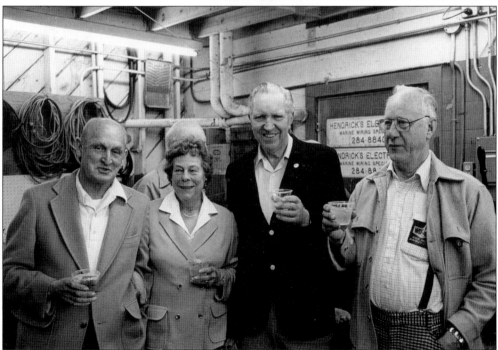

HENDRICKS ELECTRIC 20TH-YEAR CELEBRATION, 1981. This marine wiring company is still located in Fishermen's Terminal. From left to right are Art Hvatum, Olive Svendsen, Trygve Jorgensen, and Clarence Svendsen drinking a toast to Hendricks's 20th anniversary in business. Clarence was a salesman for the Fisheries Supply Company, and Art also owned Seattle Ship Supply. All three businesses are still operating. (Courtesy Julie Svendsen.)

81

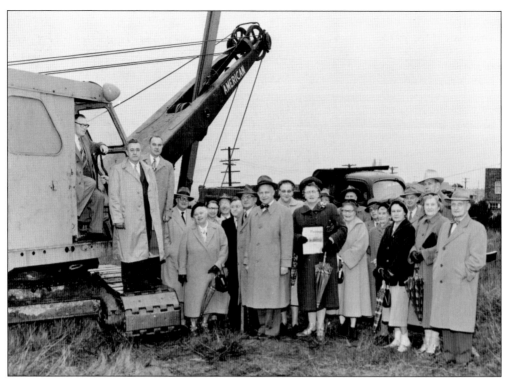

FROM HOPE TO A REALITY, 1955. The Norse Home was incorporated with the State of Washington in 1934 as an idea and an intention but without tangible assets. At the ground-breaking ceremony are, from left to right, Abraham Kvalheim, "the Father of Norse Home;" Dr. Trygve Buschmann; Paul Berg; Inga Frodesen (first woman on the left); attorney Eli Paulson; Dorothy Bjornstad (black coat); Ole Andreason; Norwegian consul Christian Stang (with the tall hat on the right); and contractor Peter Wick (with the hat on the extreme right). (Courtesy Museum of History and Industry, *Seattle Post-Intelligencer* Collection, 1986.5.1002.)

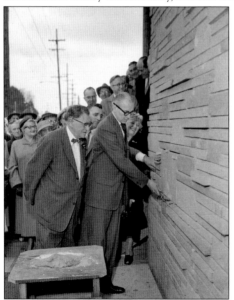

SEALING THE CORNERSTONE, 1957. Frode Frodesen is seen looking over the shoulder of R. W. McCauley from the Federal Housing Administration (FHA) in Washington, D.C., as the cornerstone of the Norse Home is sealed in April 1957. Architect Ed Mahlum convinced Senators Henry Jackson and Warren Magnuson to pass a federal program to finance homes for the elderly, and the Norse Home became the first to receive an approved and guaranteed loan from the FHA. (Courtesy Museum of History and Industry, *Seattle Post-Intelligencer* Collection, 1986.5.1003.1.)

PETER WICK CONSTRUCTION, 1948. Peter D. Wick (left) emigrated in 1913 from Syrde, Norway. With Charles Dahlgren (center), he started Wick and Dahlgren, which built apartment buildings before World War II. Later, as Wick Construction, which formed in 1951, Wick built the Norse Home and Hearthstone Retirement Center. Peter Wick received the St. Olav Medal in 1962. Andrew Wick is on the right. (Courtesy Nordic Heritage Museum, 2001.173.002.)

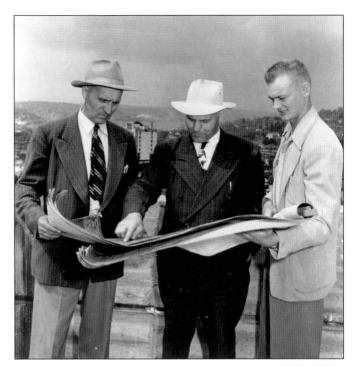

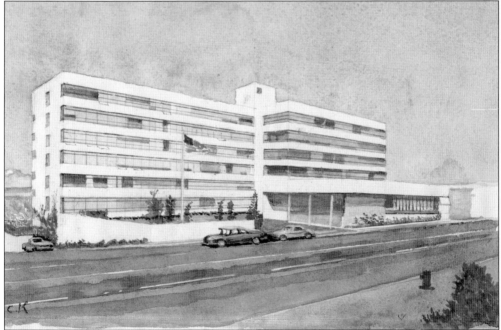

CROWN OF THE COMMUNITY, THE NORSE HOME, 1957. Since early days, many local Norwegians realized the need for a comfortable home for their retired people. Conversations about a "Sons of Norway Home" started in the late 1920s, and the property on Phinney Avenue overlooking Ballard was purchased in the 1930s. The name was changed to the Norse Home, and fund-raising went on for decades. It was completed in 1957 for approximately $1.2 million. (Courtesy Anne Marie Steiner.)

NORWAY CENTER, 1970s. The Sons and Daughters of Norway clubs and the Norwegian Male Chorus together built the 39,000-square-foot building for a cost of $225,000 in 1950. Slate from a Norwegian mountain was imported for the entry. It featured a 900-seat auditorium, a banquet hall, rooms for music and meetings, and a seafood restaurant—the Norselander—on the top floor with a view of Elliott Bay. Many still remember dancing in the ball room and other good times in the Viking Room of the Norselander. In 1983, it was sold to the Mountaineers and in 2008 to a developer who plans to raze the building. (Courtesy Leif Erikson Lodge of the Sons of Norway.)

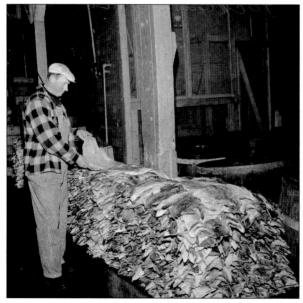

LUTEFISK SHIPMENT, 1949. The traditional Christmas dinner in Norway varies by region of the country, but a December lutefisk dinner, either at church, at the Sons of Norway hall, or at home, became a Norwegian American tradition. Jack Gaskerol is shown with a pile of lutefisk in a *Seattle Post-Intelligencer* photograph from December 12, 1949. (Courtesy Museum of History and Industry, 1993.20.213.)

**NORSE HOME ARCHITECT MAHLUM,
C. 1957.** Edward Kristian Mahlum
was born in America but was raised in
Norway. His grandfather and father had
been master woodworkers in Norway,
and he was selected to design the Norse
Home in the late 1940s. Mahlum also
designed the Norway Center (1951) and
numerous retirement homes and schools.
He received Norway's Medal of Freedom
after the war. The St. Olav Medal he
received for his services to Norway is
pictured below. (Courtesy John Mahlum.)

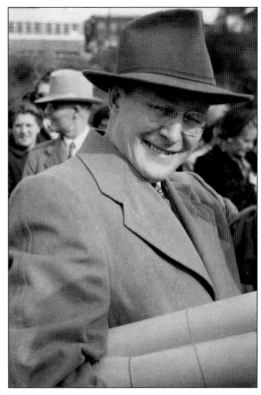

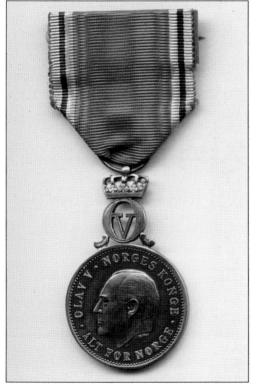

SANKT OLAVS MEDALJEN, 1962. The
St. Olav Medal is one of Norway's highest
honors. It was established by King Haakon
VII on March 17, 1939, as a reward for
services in advancing knowledge of Norway
abroad and for strengthening the bonds
between Norway and expatriate Norwegians
and their descendants. On June 17, 1962,
at the Leif Erikson statue unveiling on
Norway Day at the Seattle's World's Fair,
eight local men received the award—Paul
Berg, Frode Frodesen, Rev. O. L. Haavik,
Andrew J. Haug, Edward T. Mahlum,
Trygve Nakkerud, Henry Ringman, and
P. D. Wick—for their duty and service
to Norway. (Courtesy John Mahlum.)

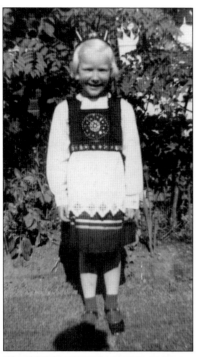

MAY 17, 1947. Sonja Coien, age 7, wears her cousin's Hardanger *bunad* for the 17th of May program at the Civic Auditorium. Sonja remembers being proud to march in the parade but was bored by the speeches that followed. Families and friends passed children's *bunads* around to make sure that everyone wore one on the 17th of May. (Courtesy Sonja Beck.)

"COSTUMES BRIGHT AND GAY, FOR THE 17TH OF MAY," 1970. The year celebrated the 25th anniversary of Norway's liberation from Germany's occupation on May 8, 1945. Ralph Cohen of Scandinavian Airlines gave the main address. Even though he was not Norwegian, his words were stirring: "As an American and a human being, then, I find no difficulty saying, '*Lenge leve Norge*' [Long live Norway]." (Courtesy Museum of History and Industry, 1986.17343.1.)

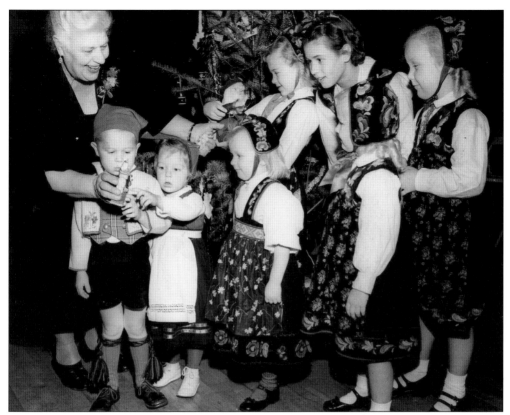

NORWEGIAN HOSPITAL ASSOCIATION'S CHRISTMAS PARTY, 1955. Inga Frodesen, past president of the hospital association, is shown handing out candy to (from left to right) Olav Norman Ruud, Karen Ruud, Janet Frodesen, Rose Marie Murphy, Carol Eastvold, John Arnason, and Olivia Arnason. They also had music and children's dances that day. (Courtesy Anne Marie Steiner.)

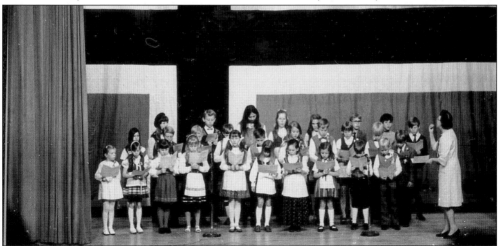

17TH OF MAY AT NORWAY CENTER, C. 1964. Lillian Christoffersen leads the children of the community in a 17th of May song. The giant Norwegian flag was often present in the background for celebrations at Norway Center. Lillian was also an elementary school teacher and played the accordion. She enjoyed anything to do with children's music. (Courtesy Anne Marie Steiner.)

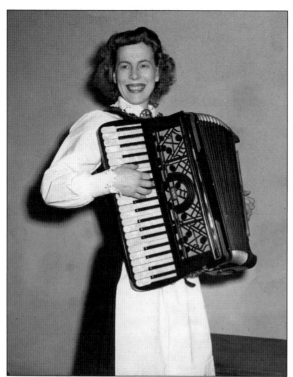

CHILDREN'S CHORUS DIRECTOR OLIVE SVENDSEN, C. 1948. Olive learned to play the accordion as an adult after Gerke's Appliance and Music Store in Ballard told her they needed an accordion teacher. Although she had never played accordion, she practiced and became accomplished at it. She also conducted a children's chorus that practiced in the family home in the 1950s. (Courtesy Julie Svendsen.)

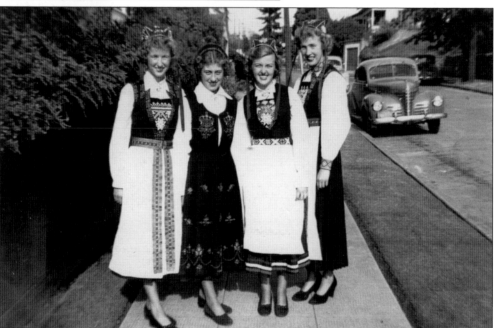

17TH OF MAY, C. 1947. From left to right, friends Eleanor Coien, Oddny Strom, Nellie Foss, and Bernice Coien are dressed for the 17th of May celebration at Seattle's Civic Auditorium. The traditional parade was held inside, followed by speeches and a program. The Coien family was from Rissa, and the girls should have worn Tronder *bunad* dresses, but they preferred Hardanger *bunader* borrowed from their aunt. (Courtesy Sonja Beck.)

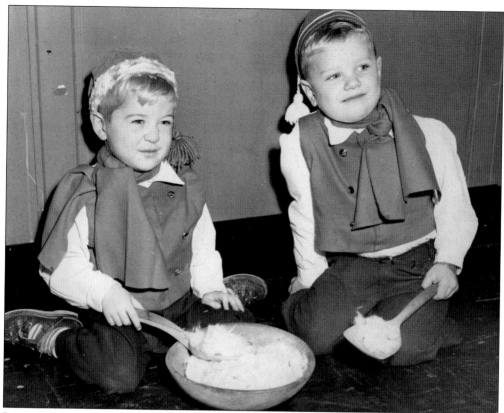

LITTLE TOMTE SERVING PORRIDGE, 1958. Cousins Don Murphy (left) and Fred Frodesen are dressed up for a *julefest* party for one club or another, probably at the Norway Center. *Tomte* (elves)—either dolls or children in costume—are often featured as part of the Christmas celebration in Norway because it is considered good luck to feed the farm's creatures during the winter solstice. (Courtesy Glory Frodesen.)

NEIGHBORHOOD CHILDREN ON THE 17TH OF MAY, 1957. Some of the women in the community, such as Inga Frodesen, had enough *bunad* costumes to dress their nieces, nephews, and the neighborhood children too. From left to right, (first row) Lois Miner, Janet Frodesen, Charlotte Miner, and Freddy Frodesen; (second row) Ginnie Andersen, Carol Frodesen, Jeanne Frodesen, and Glory Frodesen prepare for the parade. (Courtesy Glory Frodesen.)

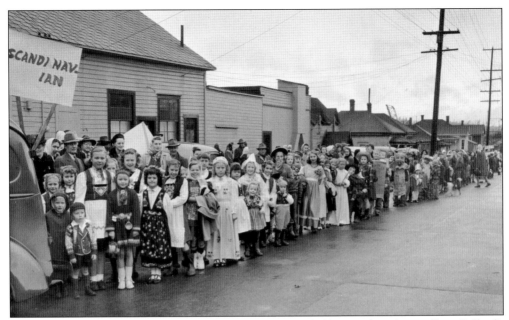

SCANDINAVIAN CHRISTMAS FESTIVAL PARADE, 1948. Children gathered to walk in Ballard's annual Christmas parade on a rainy Sunday, December 12, 1948. Many children are dressed in Norwegian folk dress or *bunad* costumes, and others are dressed in make-believe costumes. The point seems to be to dress up for the parade. (Courtesy Museum of History and Industry, *Seattle Post-Intelligencer* Collection, 22495.)

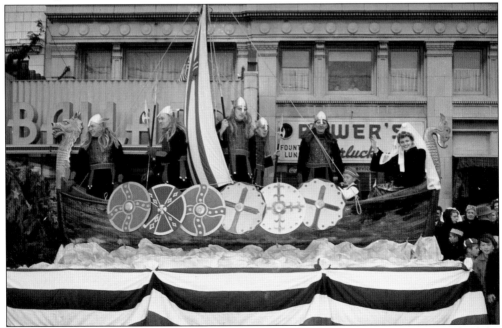

SCANDINAVIAN CHRISTMAS FESTIVAL PARADE, 1948. The Norwegian Commercial Club's Viking boat float won first prize in Ballard's Christmas Festival parade. Ray's Boat House restaurant cosponsored it, and Asa Gudjohnsen rides the float, manned with an authentically helmeted crew. (Courtesy Museum of History and Industry, 1986.6.7343.1.)

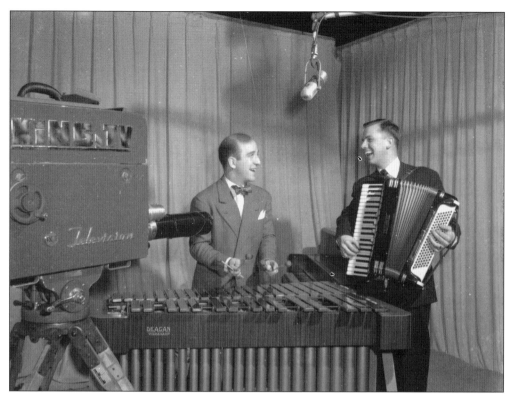

THE KING OF SCANDINAVIAN HUMOR, STAN BORESON, 1950. In the tradition of Scandinavian vaudeville, Stan (right) is an extremely popular entertainer. He had a long-running children's television show, *King's Klubhouse*. Following that, he became known for using a Scandinavian dialect on his altered renditions of well-known songs. Stan has appeared on numerous shows, including *The Lawrence Welk Show* and *A Prairie Home Companion*, and—at the king's request—for King Olav V of Norway. (Courtesy Museum of History and Industry, 1983.10.17019.)

HANGING UP THE SHEAVES, 1948. Olaf Wiggen decked Ballard's streets with a tradition from Norway, *julenek*. When the land is dark and covered with snow, it is considered good luck to feed the birds, a practice that dates back to heathen times. Olaf Wiggen came from Norway and became a partner in the Pheasant Funeral Home because he could speak Norwegian. Today it is the Wiggen and Sons Mortuary. (Courtesy Museum of History and Industry, 1986.5.7334.)

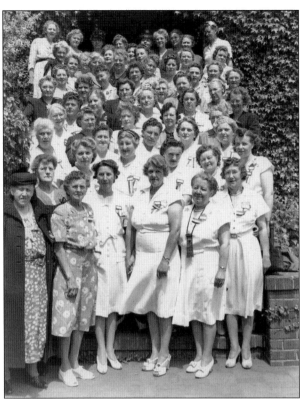

DAUGHTERS OF NORWAY DRILL TEAM, 1946. Women's drill teams were an integral part of the 17th of May parades, but the women also enjoyed the sociability of being with other Norwegian women and, in the early days, of speaking Norwegian. Just like the Sons of Norway, there was a feeling of banding together to help one another. (Courtesy Anne Marie Steiner.)

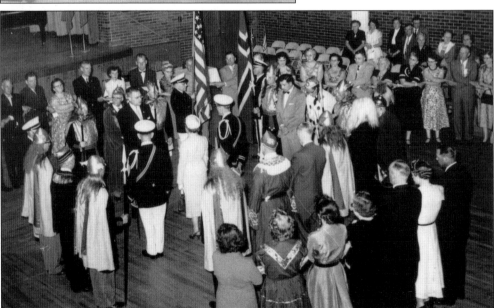

LEIF ERIKSON LODGE INITIATION, 1950S. Sons and Daughters of Norway lodges were formal in their ceremonies during that era, and a few still are. Note the people with crossed arms forming a circle around the initiates. The crossed arms express solidarity, and the words at that point in the ceremony were "united and true, til Dovre shall fall," similar to the words used by the signers of the Norwegian constitution at Eidsvoll. (Courtesy Nordic Heritage Museum, 2004.137.126.)

Scoop Jackson and His Dancing Shoes, 1952. No one knows today why Sen. Henry M. Jackson was changing socks backstage at the Scandinavian Music Festival. His son claims that he had one pair of hiking boots and 10 pairs of wing tips, so perhaps he was borrowing some dancing shoes. He enjoyed his Norwegian heritage. (Courtesy University of Washington Libraries, Special Collections, UW 27688.)

Nordic Festival, 1964. Seattle had a week-long Nordic Festival from approximately 1962 to 1978. A Nordic Queen reigned over the activities. Planning meetings were held at the Swedish Club. This joint effort of all the Scandinavian groups in Seattle led to the founding of the Nordic Heritage Museum. (Courtesy Museum of History and Industry, 1985.5.6993.3.)

INAUGURAL BANQUET FOR NORWEGIAN AMERICAN CHAMBER OF COMMERCE, 1969. The Rainier Club was the setting, and Leif Eie (standing) was the master of ceremonies for the banquet marking the new Pacific Northwest Chapter of the Norwegian American Chamber of Commerce (NACC). Einar Johnsen of Johnsen's Scandinavian Foods was the chairman of the new chapter, and Gov. Dan Evans was the honorary chairman. The goal of the organization was to promote trade between Seattle and Norway. (Courtesy Marilyn Whitted.)

JULEBORD AT THE NACC, 1987. Anne Bugge (first row, left) was the first woman president of the NACC and served for two years. Sen. Warren G. Magnuson (first row, center) and his wife, Jermaine Magnuson (first row, right), also attended the dinner. Standing from left to right are Clayton Peterson, master of ceremonies; Marilyn Whitted, secretary-treasurer for the NACC; and Leif Eie, founding member of the NACC and director of Scandinavian Airlines in the Northwest. (Courtesy Marilyn Whitted.)

ROYAL VISIT BY CROWN PRINCE HARALD, 1964. For this visit to Seattle by the crown prince (right), the Leif Erikson League asked the Port of Seattle to add lighting to the statue of Leif Erikson, particularly on the back side where the plaques were. Even though the crown prince came during the day, the port obliged the group. The man on the left is unidentified. (Courtesy Nordic Heritage Museum 1995.214.007.)

GOV. ARTHUR B. LANGLIE, C. 1948. Republican Langlie was the only mayor of Seattle to become governor, the only governor to regain the office after losing it, and the only governor to serve three terms. His Norwegian parents came west in 1909 on the inexpensive railroad fares set to attract visitors to the AYP Exposition. Langlie pioneered environmental issues and worked to protect salmon and other fisheries. (Courtesy Museum of History and Industry, SHS 8684.)

BERGEN SISTER CITY STUDENT EXCHANGE, 1983. Students took turns staying with each other's families for several months and attending each other's schools. From left to right, Arne Moen, a high school senior from Ballard; Seattle's Mayor Charles Royer; Bergen's mayor Arne Næss; and Norwegian student Ingelin Thorsteinsen are together in Bergen during Arne's stay there. (Courtesy Lynn Moen.)

BALLARD YOUTH BAND VISITS STAVANGER, 1973. Under the direction of Alf Knudsen, the Ballard Youth Band visited Norway on an eight-day concert tour from Bergen to Oslo. Knudsen and the families raised the money. From left to right are the mayor of Stavanger, student Raymond Eriksen, director Alf Knudsen, and student Diana Flynn. (Courtesy Julie Svendsen.)

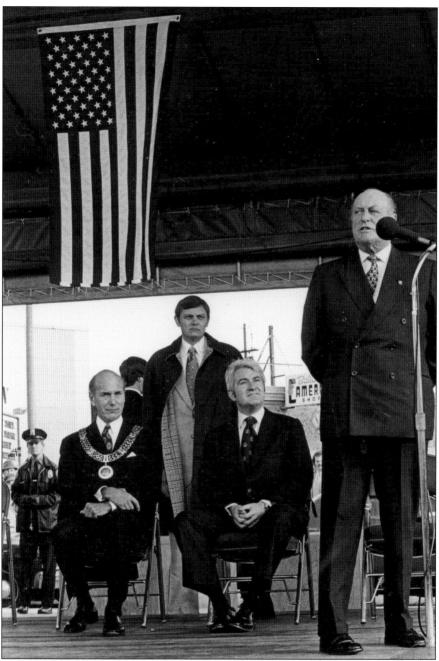

KING OLAV V DEDICATES BERGEN PARK, 1975. On an Scandinavian Airlines' flight to Bergen in 1967, Leif Eie and other locals came up with the idea of a sister-city relationship between Bergen and Seattle. Seattle gave Bergen's Nordness Park a totem pole, and King Olav V of Norway dedicated a mini-park in Ballard. In this photograph, Bergen's mayor Arne Næss (left) and Seattle's Mayor Wes Uhlman (middle) look on while King Olav V speaks at the park in 1975. On this trip, King Olav also spoke at the Ballard First Lutheran Church. After the services, he shook hands with every person there: those in the sanctuary, the balcony, and the overflow in the fellowship hall. (Courtesy Nordic Heritage Museum, 1999.068.010.)

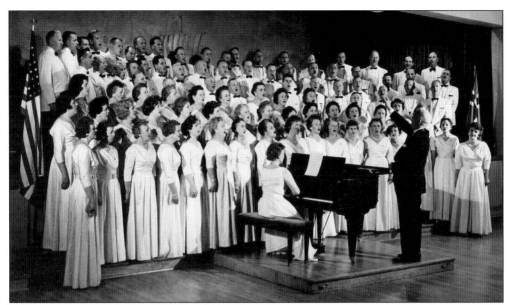

NORWEGIAN WOMEN'S CHORUS AND MALE CHORUS SING FOR THE CROWN PRINCE, 1964.
This 100-member chorus sang for Crown Prince Harald's visit to Seattle in 1968. August Werner is conducting the group, Olive Svendsen is accompanying them, and they are singing at the Norway Center in front of the large Viking mural. (Courtesy Norwegian Women's Chorus.)

AT LEAST THERE IS ONE *BUNAD* IN THE FAMILY, 1972. Here Glory Harvison and her daughter Kimber prepare for Ballard's 17th of May parade on Market Street. Just as in Norway, everyone participates in Ballard's 17th of May parade, from traditional Norwegian clubs to schoolchildren, and from high school bands to daycare centers. (Courtesy Glory Frodesen.)

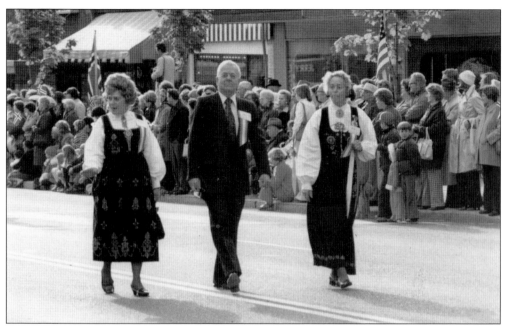

MARSHALS OF THE 17TH OF MAY PARADE, C. 1979. From left to right, Anne Marie Steiner, chairperson of the Edvard Grieg Festival; Gunnar Malmin, director of the Male Chorus in Tacoma; and Lillie Waale, secretary of the Sons of Norway, are the marshals of the parade. Seattle's 17th of May Committee selects marshals from the community. They often select a grand marshal from Norway, who also speaks at the luncheon that precedes the parade. (Courtesy Anne Marie Steiner.)

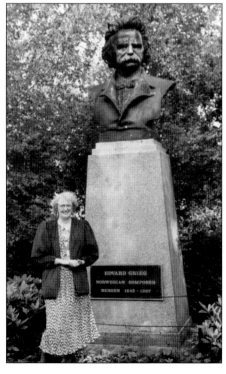

EDVARD GRIEG BUST, 1995. The bust on the campus of the University of Washington was sculpted for the AYP Exposition in 1909. Due to remodeling on the campus, it was moved and rededicated in 1975 as part of the Norwegian American Sesquicentennial. Solveig Lee, a frequent photographer of events in the community, is on the receiving end of the photograph this time. (Courtesy Solveig Lee.)

PROF. AUGUST WERNER, 1973.
Werner emigrated from Bergen
and developed a musical and
artistic career in Seattle. He was
professor of music at the University
of Washington, director of the
Norwegian Male Chorus, a prolific
painter, and the creator of Ballard's
Leif Erikson statue. Many credit
him with Seattle's interest in opera,
but his greatest legacy will probably
be, as he called it, "my boy Leif."
The photograph is by Josef Scaylea.
(Courtesy Museum of History and
Industry, 1993.20.231.)

**A VISIT TO THE HOME OF AUGUST
WERNER, 1962.** The model used to
create Ballard's statue of Leif Erikson
graced the dining room of August
Werner for many years and was often
the centerpiece of dinner parties and
photographs. He and several helpers
created the model in his dining room, as
he was a widower and could get away with
it. Here Julie Svendsen, age four, gets a
close-up view. (Courtesy Julie Svendsen.)

TRYGVE NAKKERUD AND THE LEIF ERIKSON STATUE, 1976. Trygve was tireless in his efforts to erect a statue of Leif Erikson in Seattle. It was finally given to the Port of Seattle on Norway Day at the Seattle World's Fair in 1962. Here Trygve is speaking at the Bicentennial World Marine Festival on Leif Erikson Day, October 9, 1976. To the right of Trygve is Honorary Consul Thomas Stang. Photographers enjoyed getting pictures of the statue with a pigeon on its head. (Courtesy Sig Mehus.)

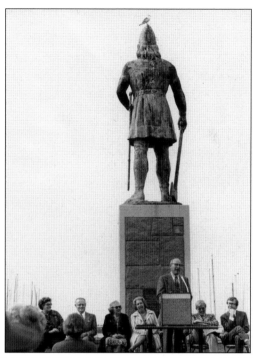

LEIF ERIKSON STAMP, 1968. The group who had been involved in the Leif Erikson statue project continued to lobby for national recognition for Leif Erikson as the first European to come to America. This stamp was issued in Seattle on Leif Erikson Day in 1968. Although it used the image of Greenland's statue and not Seattle's, the spelling of his name is the one more commonly used on the West Coast. (Courtesy the author's collection.)

SVEIN GILJE RECEIVES ROYAL NORWEGIAN ORDER OF MERIT, C. 1996. Leif Eie looks on while Hans Ola Urstad, Norwegian consul general of San Francisco, honors Svein Gilje as commander of the Royal Norwegian Order of Merit for his work planning the visit by the royal couple in 1995. Svein was also the first president of the board of trustees for the Nordic Heritage Museum. Seattle's honorary consul, Thomas Stang, is on the right. (Courtesy Solveig Lee.)

SCANDINAVIAN LANGUAGE INSTITUTE, 1990. Director Ed Egerdahl opened the doors to the language school in the late 1970s to teach Scandinavian languages. Most of the classes are in the evening, with more Norwegian classes than any other language. Tutoring, translation services, children's classes, and group tours to Norway are also offered. Here the students are marching in the 17th of May parade in Ballard. (Courtesy Solveig Lee.)

MURAL AT BERGEN PLACE, 1995. The design of the historical mural at Bergen Place in Ballard was chosen by a vote of the public. King Harald and Queen Sonja dedicated it in October 1995 and were later feted at Leif Erikson Hall and with a banquet at the Westin Hotel. (Courtesy Solveig Lee.)

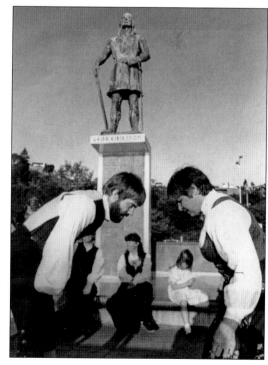

LEIF ERIKSON STATUE TURNS 30, 1992. This photograph of *Leikarringen* dancers appeared in the *Ballard News Tribune* at the 30th anniversary of the statue. Mike Shuh bows to Rosemary Antel, and Nancy Morrison is in the background. (Courtesy Rosemary Antel.)

HENNING BOE AND WESTERN VIKING, 1959. Henning Boe, who had worked at the Norwegian newspaper *Washington Posten*, purchased the paper from O. L. Eide in 1959. Henning moved it from its downtown offices at First and Cherry Streets to Ballard. By that time, most of the articles were in English. In 1961, Henning renamed it *Western Viking* to give it a broader appeal. (Courtesy Nordic Heritage Museum, 2000.010.001.)

ALF KNUDSEN AND WESTERN VIKING, C. 1997. In 1990, a group of investors purchased *Western Viking*, and Alf Knudsen became the editor. In 1997, he turned it over to his daughter, Kathleen Knudsen, although Alf continued to be involved. In 2007, the newspaper combined with the *Norway Times* from the East Coast under the editorial leadership of Jake Moe and a new name: *Norwegian American Weekly.* (Courtesy Nordic Heritage Museum, 2000.008.001.)

MISS BARDAHL GOES TO WASHINGTON, 1963. From left to right, Sen. Henry M. Jackson, Ole Bardahl, and Warren G. Magnuson are shown at the Capitol Building in Washington, D.C., in front of the national championship–winning hydroplane, *Miss Bardahl*. Ole Bardahl came to Seattle in 1922. After building a successful construction business, he bought a chemical company that produced soaps and an oil additive. He added a line of motor products and set up distributorships around the world. (Courtesy University of Washington Libraries, Special Collections, UW 27734.)

FAVORITE NORWEGIAN SONS: JACKSON AND MAGNUSON, 1969. Henry M. Jackson and Warren G. Magnuson were influential U.S. senators with Norwegian parentage. "Scoop" Jackson served from 1953 until 1983 and "Maggie" from 1944 until 1981. They were responsible for much of the funding that came into the state, from health care research grants awarded to the University of Washington to government purchases of Boeing airplanes. (Courtesy University of Washington, Special Collections, UW 19599.)

IVAR HAGLUND, C. 1950. Ivar was born in 1905 to a Norwegian mother and a Swedish father. He was a folk singer who established Seattle's first aquarium and, in 1946, his Acres of Clams restaurant. By 1966, when he began sponsoring Seattle's Independence Day fireworks display, he was a legend whose promotional stunts and quirky personality charmed the city. He died in 1985 but lives on through his restaurants and annual gift of fireworks. (Courtesy University of Washington, Special Collections, UW 18556.)

VIKING POSTCARD FOR RAY'S BOATHOUSE, 1950. The Scandinavian influence has long been evident in Ballard, even in institutions without Nordic backgrounds. This postcard with the image of a red-bearded, horned Viking was an advertising piece for Ray's Boathouse. Of course, real Viking helmets did not have horns, but it is an image used either by those who do not know or by the community itself in jest. (Courtesy Nordic Heritage Museum, 2004.101.004.)

SKIING AT SNOQUALMIE PASS, 1948. Sisters Eleanor (left) and Bernice Coien hiked up and then used wooden cross-country skis for downhill skiing at Snoqualmie Pass. There were no ski lifts, just tow ropes. They went, in part, just to watch the local Norwegian crowd who were ski jumping near the summit. (Courtesy Sonja Beck.)

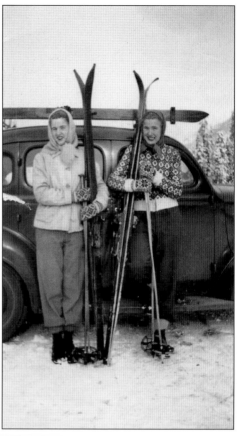

PICNIC AT MOUNT RAINIER, LATE 1940S. Chris Myer, whose name was Kristoffer Finsmyr before he immigrated, is shown here all dressed up for a picnic on the Paradise side of Mount Rainier. He worked for Seattle Public Schools and made *lefse* rolling pins and turners in a school carpentry shop for local Norwegian women. (Courtesy Sonja Beck.)

CHAMPION SKI JUMPER GUSTAV RAAUM, 1951. Gus is shown here jumping from a 90-meter hill at Leavenworth. He came to the United States as a member of the Norwegian ski jumping team, attended the University of Washington, and was named All-American there for his ski jumping. He won numerous other medals and was elected to the U.S. Ski Hall of Fame. (Courtesy Mina Larsen.)

OLYMPIC SPORTS CENTER, 1960S. Einar Pedersen bought Olympic Sports in Ballard from another Norwegian, Haakon Dalsbo, in 1961 and ran it for about 18 years. The store on Market Street featured ski equipment and also sponsored a ski school. The Olympic Sports Center at Northgate is still in operation. Later Solveig and Sverre Hatley ran the Scandinavian Shop in the same location for 28 years. (Courtesy Einar Pedersen.)

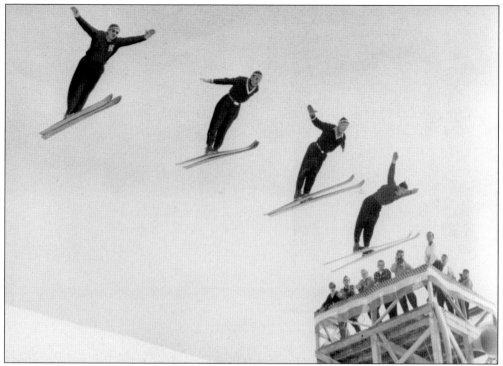

NORWEGIAN SKI LEGENDS, 1948. From left to right, Olav Ulland, Gustav Ulland, Alf Engen, and Kjell Stordalen are jumping at Ruud Mountain at Sun Valley, Idaho. Olav grew up in Kongsberg, then the ski jumping capital of Norway. He opened Osborn and Ulland in Seattle in 1941 with a partner after their friend, Eddie Bauer—founder of the outdoor-clothing retailer—loaned them about $1,000 each. Olav took his last jump at age 60. (Courtesy Mina Larsen.)

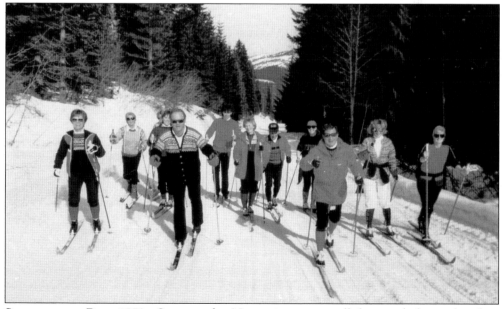

SKIING AT THE PASS, 1970s. Some say that Norwegians are actually born with skis on their feet. This group is at one of the mountain passes for a day's ski. (Courtesy Mina Larsen.)

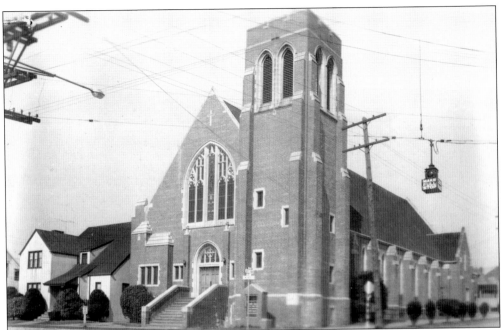

BALLARD FIRST LUTHERAN CHURCH, 1950S. The church formed as the Zion Evangelical Lutheran Church in 1894 and combined with the Bethlehem Lutheran Church in 1917. The present building was dedicated in 1930. Many Norwegian religious events are marked at Ballard First Lutheran—for example, a memorial service for King Olav V was held on January 30, 2001. Copies of the liturgy were faxed from Oslo to Norwegian churches outside Norway for all the memorials held the same day. (Courtesy Julie Pheasant Albright.)

REV. OLAI HAAVIK AND HIS GRANDCHILDREN, 1963. Olai Haavik emigrated from Norway in 1903 and served the Norwegian American community as pastor of the Ballard First Lutheran Church from 1921 to 1947. He initiated the blessing of the fleet and received numerous awards for his leadership, including the St. Olav Medal. Here he is talking to his grandchildren attending Pacific Lutheran University. From left to right are Olai Haavik, Janice Haavik, Jay Haavik, Joyce Haavik, Diane Haavik, and Dale Tommerick. (Courtesy Haavik family.)

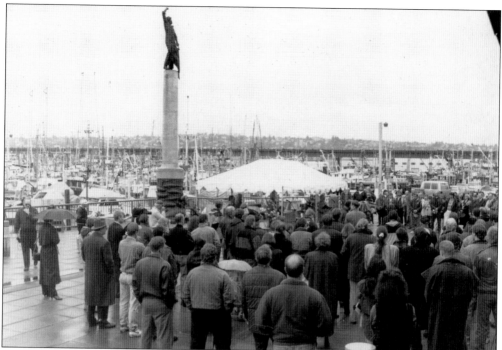

FISHERMEN'S MEMORIAL DEDICATION, 1988. The Seattle Fishermen's Memorial was established in 1985. With generous donations from the community, the organization dedicated the memorial in 1988 and subsequently added grief counseling and safety training. The sculpture and names have become a place of healing for the families of nearly 700 local commercial fishermen and women who have lost their lives pursuing their livelihood from the sea. (Courtesy Fishermen's Memorial.)

BLESSING OF THE FLEET, 1987. Pastors from the Ballard First Lutheran Church, Ben Bretheim at the podium and Malcolm Undseth in the center, lead the annual service. Ballard First Lutheran's Rev. Olai Haavik started the services in 1929. Prayers are offered for a good season, peaceful seas, a safe journey home, families waiting at home, and those who have lost their lives at sea. (Courtesy Fishermen's Memorial.)

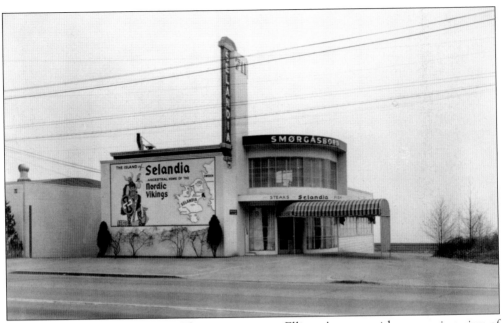

SELANDIA RESTAURANT, 1948. This restaurant on Elliott Avenue, with a sweeping view of the sound, was a favorite of many Norwegians even though it was owned by Danes. It featured an authentic *smørgåsbørd* and lace tablecloths, and was recommended by Duncan Hines. A fictitious "Island of Selandia, Ancestral Home of the Nordic Vikings" was portrayed on the side of the building. (Courtesy Museum of History and Industry, 1983.10.16743.)

TWO GOOD REASONS TO VISIT BALLARD, 1965. Einar Johnsen started a food store next to the Norseman Cafeteria on Market Street in 1960. When he opened a bigger store across the street in 1963, he named it Johnsen's Scandinavian Foods. In 1972, he sold it to Reidar and Ebba Olsen, and the name was eventually changed to Olsen's. In 1997, it was sold again to sisters Anita and Reidun Endresen, who continue to own it today. (Courtesy Olsen's Scandinavian Foods.)

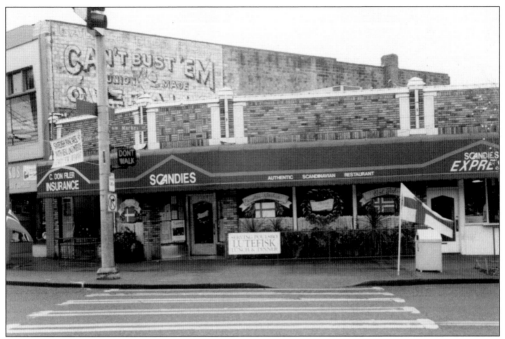

SCANDIES RESTAURANT, 1994. Finnish owner Tom Miller ran Scandies from 1982 until 1998 and was supportive of the entire Scandinavian American community. He served lutefisk at Christmastime, a smorgasbord with pickled herring and meatballs on Friday nights, and brunch with Swedish pancakes and lingonberries on Sundays. About Sundays, Tom would tell guests, "Come early, because it starts filling up when the Lutheran churches end about noon." (Courtesy the author's collection.)

THE MUSEUM'S THURSDAY CREW, C. 1990. These men volunteered faithfully every Thursday on anything that needed to be done around the museum—including drinking coffee. From left to right are Paul Asheim, Joe Kroeger, Wayne Mellroth, Tor Berg, Carl Aspelund, Olaf Rockness, director Marianne Forssblad, Clarence Pedersen, John Hendricks, Buz Andersen, Trygve Jorgensen, and Marvin Meyers. Trygve Jorgensen started the group in 1980. (Courtesy Nordic Heritage Museum.)

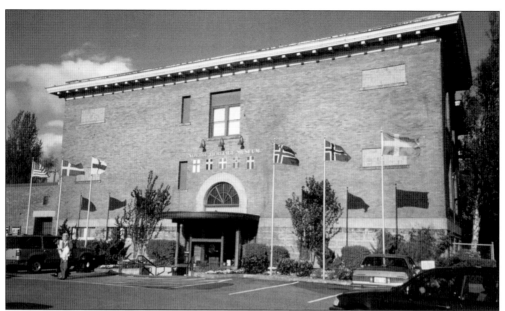

NORDIC HERITAGE MUSEUM'S EARLY DAYS, C. 1983. The museum arose from a cooperating group of Scandinavian clubs, the Nordic Council (1962–1978), with this goal, as stated in 1978: "Our goal is to establish a cultural center where Scandinavian artifacts may be assembled and displayed before they are lost, and working together, we surely will be able to accomplish this." The museum's first permanent home was the Webster Elementary School, rented from the Seattle School District. It opened in 1980 with two small galleries on the second floor. Note that the windows were boarded up, and the blackboards were covered with burlap. It was tirelessly supported by executive director Marianna Forssblad and a large group of volunteers. (Both, courtesy Nordic Heritage Museum.)

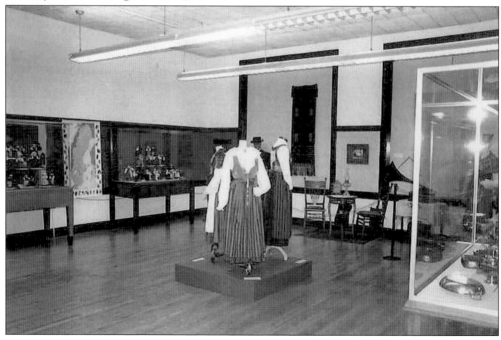

Four

From Scandinavian Dance to Deadliest Catch

1990 to 2008

Seattle's contemporary Norwegian community is busy and thriving. The *Seattle Times* called it "one of the most-vibrant Norwegian-American communities in America." Changes occur, and people and clubs come and go, but the strength of the community and its traditions remain: the number of King County residents claiming Norwegian heritage grew by 3,000 in the years between 1990 and 2000; Seattle's 17th of May parade is considered the biggest outside of Norway; a reality television show about some Seattle-based Norwegian crab fishermen is award-winning and popular; the Leif Erikson Lodge of the Sons of Norway is the largest lodge in the world; community-based Norwegian language classes are offered several evenings a week; Norwegian studies at the University of Washington attract students from across the country; Norwegian flags hang on the main street of Ballard; a Leif Erikson dinner still happens every October 9; and those with an itch to travel to Norway can do so, and do it regularly.

The strength of the community comes directly from the individuals who are leading it and those who came before them. Visionary leaders made sure that there are places to meet, such as *Kaffestua* and the Leif Erikson Lodge, retirement places such as Norse Home, and recreational spots such as Norway Park. Visionary leaders have kept the history alive through the Nordic Heritage Museum and the University of Washington. These leaders were dedicated to seeing that a 50-year-old Scandinavian radio show and a 110-year-old Norwegian newspaper kept going. They make sure that descendents keep their ties not only to Norway of the past, but to Norway of the present and the future through student and professor exchanges, study tours, the purchase of products from Norway, and the welcome shown to *nye nordmenn* who are coming for jobs in technology or to study. The community will continue to flourish.

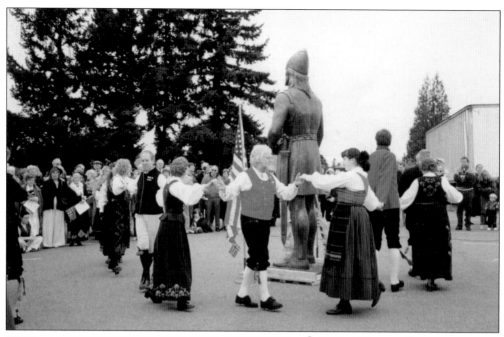

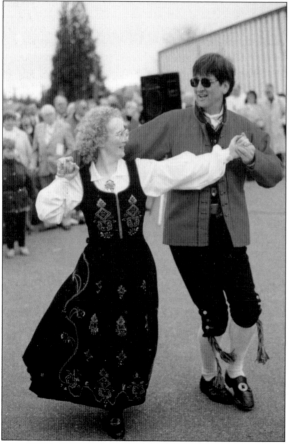

CELEBRATING THE STATUE WITH DANCE, 1997. A group in Seattle raised funds to give a replica of Seattle's statue of Leif Erikson to Trondheim, Norway, for its 1,000th anniversary. Before being shipped, the 10-foot statue was taken to the parking lot of Our Redeemer's Lutheran Church for a blessing ceremony. Above, from left to right, Dale Abraham, Carol Ollestad, Richard Lowe, Ingrid Hamberg, Larry Reinert, and Marietta Ronnestad do a circle dance around the statue. At left, longtime *Leikarringen* dance instructors Lori Elken and Larry Reinert also perform for the crowd that gathered, mostly donors to the project. (Above, courtesy the author's collection; left, courtesy Solveig Lee.)

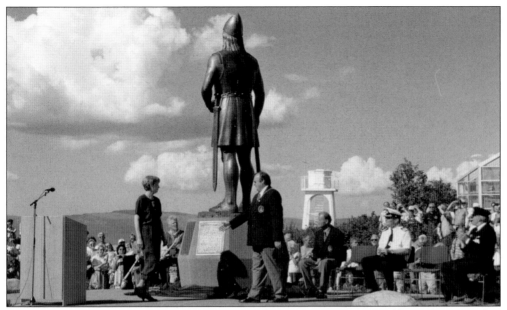

LEIF TRAVELS TO NORWAY, 1997. The Leif Erikson Society was a small Seattle group that formed to raise the funds to give the statue to Trondheim. Kristine Leander from Seattle and Trondheim's Mayor Marvin Wiseth have just unveiled the statue near the water's edge in Trondheim's harbor. Around 3,000 gathered for the first glimpse of the gift. Donors gave in honor of immigrants to America, whose names were placed on bronze plaques near the statue. (Courtesy the author's collection.)

NORWEGIAN VIKING IN THE ICELANDIC ROOM, 2001. Leif Karlsen was born in Norway and went to sea at the age of 15. After he retired, he wrote a book on Viking navigation and described the use of the *solarsteinn* (sunstone). Seattle's Icelanders made him an honorary Icelander. He is shown here in the Icelandic Room of the Nordic Heritage Museum with his sunstone, his painting of a Viking ship, and a bust of Leif Erikson. (Courtesy Nordic Heritage Museum.)

OLAF KVAMME, 1998. Olaf worked for nearly 40 years in the Seattle public schools as a teacher, principal, and assistant superintendent. After he retired, he was president of the board of the Nordic Heritage Museum for a number of years, the Bergen Sister City organization, and a member of the University of Washington Scandinavian Department's advisory board. Even though he has served as the president of the board, Olaf knows his way around the kitchen of the museum. (Courtesy Nordic Heritage Museum.)

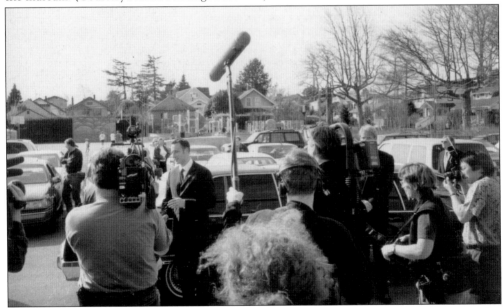

THE FUTURE KING OF NORWAY MEETS THE MEDIA, 1999. Crown Prince Haakon made his first official visit to the Pacific Northwest in 1999. Here he visits the Nordic Heritage Museum, where he is met by a barrage of journalists. The crown prince traveled across the country, visiting Norwegian American communities along the way, after he graduated with a degree in political science from the University of California, Berkeley. (Courtesy Dean Wong.)

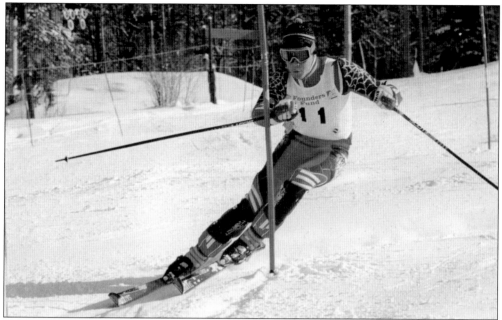

SKIING HAS COME A LONG WAY, BABY, 1995. Arne Svendsen is shown here in a college ski competition. He is the grandson of the Olive Svendsen in Chapter Two of this book, who shared a pair of skis with her cousin and walked to the top of the mountain for one trip down each day. (Courtesy Julie Svendsen.)

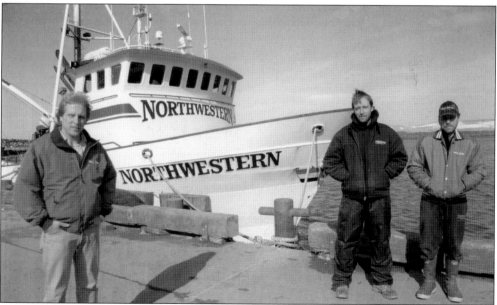

DEADLIEST CATCH, 2007. *The Deadliest Catch* is a documentary-style reality television series on the Discovery Channel. Sig Hansen (left) of Seattle is a fourth-generation Norwegian fisherman and the captain of one of the legendary fishing boats on the show, the *Northwestern*. Sig has been prominently featured in the series and also serves as technical advisor to the production. He is shown here with his brothers Edgar (center) and Norman (right), who also work aboard the ship. (Courtesy Sig Hansen.)

BRINGING IN THE SHEAVES, C. 1998. Carolyn Davis and her family lived in Norway for a year and learned the tradition of hanging up a sheaf of grain for the birds around the time of the winter solstice. Her family has reinstituted the tradition in Ballard by hanging them on the trees along Market Street and selling them in front of Olsen's Scandinavian Foods for the public to purchase for their homes. (Courtesy the author's collection.)

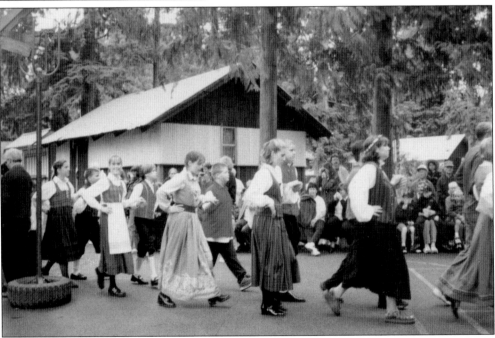

NORWEGIAN LANGUAGE CAMP, 2002. With a membership of 1,700, the Leif Erikson Lodge of the Sons of Norway actively supports numerous activities and programs, including the Kaffestua social center; the Leikarringen dance group for adults; and the *Barneleikarringen* dance program for children and families. It also sponsors language and other heritage classes to introduce younger members to Norwegian culture and funds a scholarship program for youth camp counselors and instructors. (Courtesy Julie Svendsen.)

PROF. TERJE LEIREN, LATE 1980S.
Professor Leiren has been on the faculty of the Scandinavian Studies Department at the University of Washington since 1977 and has served as the department chair since 1995. He generously gives his time to the community and is often present at local events. At the university, he teaches third- and fourth-year Norwegian language and culture courses. (Courtesy Solveig Lee.)

FRIENDSHIPS AT NORWEGIAN LANGUAGE CAMP, 2002. The mothers of, from left to right, Kari Schmidt, Kjersti Sangrey, and Marit Schmidt have sung together for many years in the Norwegian Ladies Chorus of Seattle, and the girls have spent time together since their childhood. All are interested in learning Norwegian and furthering the culture. Kari returned in 2008 from spending a year at a *folkehøgskole* in Norway. (Courtesy Julie Svendsen.)

THE RON AND DOUG SHOW, 2004. Starting in their college years, Ron Olsen (left) and Doug Warne (right) teamed up to host the *Scandinavian Hour* on Saturday morning radio. The show combines music from Scandinavia with announcements of local events sponsored by Scandinavian groups, as well as advertisements for local Scandinavian businesses. It was heard most recently on KKNW AM 1150 on Saturday morning at 9:00 a.m. The community was deeply saddened by Ron's death in the spring of 2008. (Steve Ringman, the *Seattle Times*.)

BERGLJOT ROSWICK AND HER DANCE STUDENTS, C. 1995. Bergljot was one of the first dance instructors for Leikarringen, the instruction and performance dance group associated with the Leif Erikson Lodge of the Sons of Norway, when it started in 1961. Later she taught folk dancing to countless children in the community. (Courtesy Solveig Lee.)

MUSICIAN ARNE THOGERSEN, C. 2000.
Arne emigrated from Norway with the reputation of "Norway's Elvis Presley." He coled a dance band, the Wild Turkeys, for many years, ran a travel agency, and went to Kaffestua in the Leif Erikson Lodge for coffee twice a day for years. He and his wife, Lillian, had nine children, most of whom they adopted, and Arne was a founder of the adoption agency World Association for Children and Parents (WACAP). (Courtesy Solveig Lee.)

NORM MALENG LEARNS ABOUT HIS FAMILY IN NORWAY, 2007. Just before King County prosecutor Norm Maleng's untimely passing, he received genealogy help from Diana Erickson (right) and discovered relatives living in Norway. He and his wife, Judy (left), planned a trip there. After his death, his brother made the trip, and in 2008, family members visited Seattle and the Norm Maleng Regional Justice Center, which was named in his honor. (Courtesy Diana Erickson.)

SANTA VISITS OLSEN'S SCANDINAVIAN FOODS, 2006. Organized by the Ballard Chamber of Commerce, Santa Claus (played by Alf Knudsen) visits with, from left to right, Anneline Skjølingstad, Reidun Endresen, Kevin Osterhout, and Cristin Osterhout at the store on Market Street. Reidun and her sister, Anita Endresen, bought Olsen's in 1997. They retained the name and the recipes from the Olsen family, who had owned the store for the previous 25 years. (Courtesy Olsen's Scandinavian Foods.)

JAY HAAVIK AND A RUNIC STONE, 2008. The Leif Erikson International Foundation moved Seattle's statue of Leif Erikson to a new base in 2007. Viking artist Jay Haavik created 13 runic-like stones to encircle the statue. Jay is the grandson of Pastor Olai Haavik and is shown here with the St. Olav Medal his grandfather received at the statue's original dedication in 1962. The project was funded by donations in honor of immigrants whose names were placed on plaques on each stone. (Courtesy the author's collection.)

SCANDINAVIAN SPECIALTIES, 2008. The store opened its doors in 1962 as the Norwegian Sausage Company, using equipment from Norway to make the sausages. Present owners Anne-Lise Berger and Ozzie Kvithammer moved the store to a new, larger Ballard location, where there is now enough space for a café and Scandinavian lunches. Anne-Lise is here with employee Tor Skeie. (Courtesy the author's collection.)

MAKING DINNER, C. 2002. Obert Ronnestad (left) has taught folk dancing to the children of the Barneleikarringen dance group for many years with his wife, Marietta. Wes Foss (right) was an attorney with the Perkins Coie law firm who generously helped Scandinavian groups, such as the Leif Erikson International Foundation, the Nordic Heritage Museum, and the Scandinavian Language Institute with their legal work, helping them to thrive as nonprofit organizations. Here the two making dinner for a lodge event. (Courtesy Solveig Lee.)

MARSHALS FOR THE 17TH OF MAY PARADE, 2008. Popular Norwegian singer Hanne Krogh (left) came to Seattle to be the parade's grand marshal. The local honorary marshals were Ted Fosberg, the international president of the Sons of Norway, and Ballard resident Elie Glaamen, who turned 100 years of age in 2008. (Courtesy Solveig Lee.)

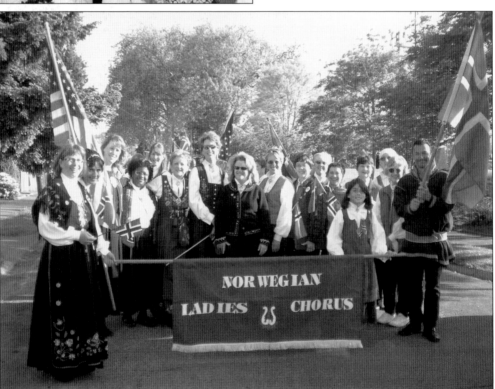

NORWEGIAN LADIES CHORUS, 2007. The chorus, founded by August Werner in 1936, is still going strong 70 years later. A visiting Norwegian Sami scholar at the University of Washington, Bård Berg, is holding the Norwegian flag on the far right. (Courtesy Barbara Grande Dougherty.)